BRISTOL
A Portrait
1970–82

Stephen Dowle

AMBERLEY

First published 2019

Amberley Publishing
The Hill, Stroud, Gloucestershire, GL5 4EP
www.amberley-books.com

Copyright © Stephen Dowle, 2019

The right of Stephen Dowle to be identified as the Author
of this work has been asserted in accordance with the
Copyright, Designs and Patents Act 1988.

ISBN 978 1 4456 9044 5 (print)

British Library Cataloguing in Publication Data.
A catalogue record for this book is available from the
British Library.

Origination by Amberley Publishing.
Printed in Great Britain.

ACKNOWLEDGEMENTS

I have referred to a number of books from my own shelves, in particular *Bristol: An Architectural History* by Andor Gomme, Michael Jenner and Bryan Little (London, Lund Humphries, 1979), and the excellent 2011 revision, by Andrew Foyle, of the North Somerset and Bristol volume in the Pevsner 'Buildings of England' series, published by the Yale University Press. The spelling of Redcliffe/Redcliff is a minefield, even for Bristolians; I have used as my authority a Geographia street atlas of Bristol, undated, but in my possession since the early 1970s. I have sought enlightenment on certain questions among the many volumes of the late Reece Winstone's 'Bristol As It Was' series, and in two further volumes, covering the 1960s, 1970s and 1980s by his son, John. I now live on the opposite side of the country from Bristol and have been compelled in some cases to use Google's Street View to check on changes since the photographs were taken. I am hopeful that no errors have resulted. Readers who wish to know more about the larger history of the post-war planning and redevelopment disaster in Britain are directed to Mr Christopher Booker's 1979 BBC documentary *City of Towers*, which has lately found its way onto YouTube.

INTRODUCTION

'Blimey,' I thought, gazing down over the tops of the advertisement hoardings from my vantage point high above the pavement, 'It's like something out of Max Ernst.' I glanced into the mirror at the top of the stairs to make sure my passengers were safely aboard and gave my driver a smart 'ding-ding' on the bell. 'Any more fares please?'

I had joined the Bristol Omnibus Company a few weeks before, in April 1970. I'd completed my week at the Lawrence Hill training school, passed the exam (nobody had ever been known to fail), done a couple of days under the supervision of an experienced conductor and was now 'out on my own'. What I'd seen from the top deck of my bus were the ruins of Newtown. The name seems to have died with the district, but Newtown had been the area of tightly packed streets lying between Clarence Road, Easton, and the railway at Barrow Road.

With a grunt of cog teeth, the bus groaned away from the kerb. I descended the stairs and hung out from the open rear platform into the rush of air, holding onto a stanchion pole. In the gaps between the hoardings, or where side streets joined the main road, I beheld the same prospect of levelled rubble, now, with spring well-advanced, becoming drowned under dandelions and grasses and shimmering faintly in the mid-morning warmth. Here and there lamp posts or telegraph poles remained, and the footings of walls broke through the cover of vegetation. Overlooking the scene were the giant gasholders (popularly 'gasometers') at Day's Road, one large and one small, making a pleasing 'mother and child' pair. Beautiful is probably not the correct word, but in its uncanny way, I thought it a magnificent sight.

The ruins of Newtown. The kerbs, pavements and setts of vanished streets could still be traced amongst the rubble. This had been Clarence Place. Lamp posts remained, but, for some reason, always with the lamps removed. In the distance are the gasholders in Day's Road. The photograph was taken on Friday 1 May 1970, a few weeks after I began working on the buses.

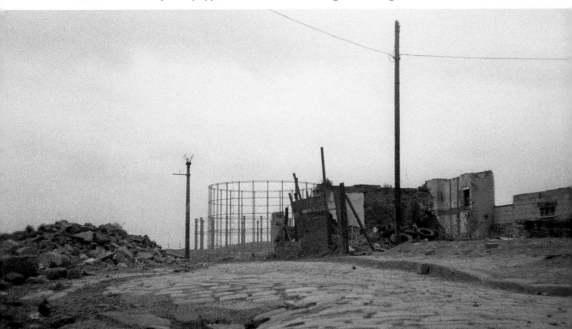

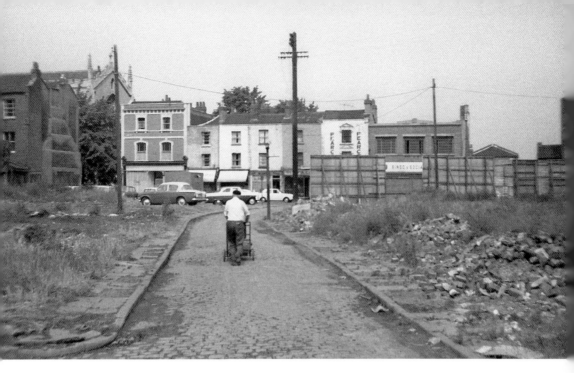

The opposite view along Clarence Place, looking towards the Kingswood main road, at this point called Clarence Road. Several times a day, I passed by on the No. 8 bus service from Warmley to Southmead. It was now Wednesday 10 June 1970, and outlines are softened as the rubble disappears under grass and nettles. Along the main road, advertisement hoardings screen all this unsightliness from the public gaze. Far off among the weeds, I spotted a yellow hut and some vans belonging to the George Wimpey construction firm. New houses arose, one of which became the focus of worldwide attention a few years later when the first 'test-tube baby' was born to parents living in one of them. Holy Trinity, St Philip's (popularly 'Trinity Church'), whose roof can be seen, top left, is all that remains of this view.

This was a minority view. The advertisement hoardings must have been erected along Clarence Road with some idea of screening the thing from view, as though shielding the public from an affront. Often, in the months that followed, I saw my passengers look disapprovingly down from their seats and mutter that the area wanted tidying up, or that the council ought to 'do something about it'. This always sent a pang of dread through me: Newtown became one of several personal sanctuaries and brooding places, all of which I loved with a proprietorial fervour. As spring passed into summer, I came often to wander among the weeds and bricks. An aroma of crushed foliage and damp plaster rose from the ground as I stumbled into suffocating pockets of heat. I would concede that much of my enjoyment dwelt in the knowledge of its brevity. My idyll was doomed, and in the loss and the losing there resided a morbid pleasure. Newtown was at the halfway stage of what had, in recent times, become a familiar process – 'redevelopment'. Deception lurked in the word, which seemed to suggest an improvement, but really signified the substitution of the worse for the better.

When I was around twelve, my father had given me an old camera of his. It was the Coronet Cub, a rudimentary instrument of pre-war date, with fixed focus, aperture and shutter speed. Apart from taking it on the school outing to Berkeley Castle, I had

not used it much – the cost of film and processing being too great for my weekly 5s pocket money. Since I had begun working on the buses, however, the weekly wage packets, agreeably plump with pound notes and weighty with half-crowns, had placed my personal exchequer in healthy balance-of-payments surplus. My first impulse on once again taking up the camera was to aim it at objects and places that were soon to disappear or change; what is photography, after all, but a means of recording appearances? I first used it to photograph steam locomotives and northern industrial towns. The kind elderly gentleman who managed the Staple Hill branch of Hodders, the chemist, now began ordering supplies of the obscure Kodak VP828 film especially for me. It was in Newtown that I started taking photographs around Bristol. The results from these early attempts were not altogether satisfactory, and in December 1973 I bought a new camera, a Praktica LTL. This was succeeded, in May 1979, by a Chinon CM3. I took the photographs as purely a personal record, with no thought of eventual publication. Being from those parts myself, I was naturally more interested in the east side of the city, and the reader will not, I hope, be disappointed by an easterly bias in the book's contents.

I was born in 1950 in my widowed maternal grandmother's house in North Street, Downend. My parents had met before the war when they both worked at Carson's chocolate factory at Shortwood. Their first marital home had been a tiny rented cottage in Mangotsfield. I believe I lived there briefly in infancy, but in an arrangement not uncommon at the time, we all moved in with my grandmother. Neither of my parents ever learned to drive; consequently, my early impressions of the world beyond our local streets were closely linked to public transport. For our everyday needs, my mother patronised the shops in Staple Hill, preferring them to their slightly closer counterparts in Downend. More elaborate requirements, of which there were few, meant a trip 'in town' on the bus.

These bus rides into town, usually on the No. 4 from Staple Hill, were, to me, tremendously exciting. By the earliest occasions I can remember, the new Broadmead Shopping Centre was complete in its essentials. The last major addition was the Co-op's Fairfax House department store, which didn't open until 1962. The Co-op's old store in Castle Street, one of the few buildings of the pre-war shopping centre to survive the bombing, continued trading until it was ready. I have dim recollections of queuing up with my mother on an upper floor for payment of accrued 'divi', the means by which the Co-op ('Cwop' as my mother pronounced it) returned a portion of its profits to its customers. The Castle Street Co-op was, I think, one of those stores that had a species of overhead cable railway connecting every till to a central cashier, usually a middle-aged spinster in horn-rimmed spectacles, seated high in a pulpit-like structure with a cup of tea and Petit-Beurre at her elbow. A metallic container, freighted with our money, shot across the ceiling and returned moments later with the change and receipt. I thought this was one of the wonders of the world.

Outside, this most ancient part of the city lay in ruins. I stared down from the pavements into overgrown, rubble-clogged cellars. Most bomb damage was caused not by explosives but by incendiaries, which burned out the interiors of buildings, leaving the walls standing. With a shiver and a sensation of 'butterflies', I looked up and saw soggy tatters of pre-war wallpaper and the imprints of cupboards, shelves

and flights of stairs. Bomb sites had a characteristic flora, and I have never since caught a whiff of elder flowers without thinking of those early shopping trips and the promise they bore (conditional upon good behaviour) of a milkshake in the cafeteria on the mezzanine floor of Woolworths before we boarded the bus to take us home. The bomb sites were gradually cleared of their rubble down to basement level, leaving the streets raised up, as though on causeways. In time, the cleared spaces were used for car parking.

My mother, a renowned worrier, was convinced that if I went out alone I would inevitably drown, be kidnapped by gypsies, fall down a hole or be set upon by footpads and – an idea probably picked up from a 'shock issue' of the *Daily Mirror* – lost forever in the white slave trade among 'dens of vice' in the Far East. In fairness, it should be remembered that the Sheasby murder case of 1957 had created an atmosphere of anxiety among all parents in our part of the city. In the end, of course, she had to give in to my ceaseless entreaties (or 'bellyaching' as it was known) and, from around the age of eleven, forewarned against accepting lifts, frequenting lonely places and taking sweets from strangers, I was allowed to go into town unaccompanied. The possibilities of the museum, Lewis's roof garden and the joke shop on Christmas Steps were soon exhausted, and I wearied of such traditional schoolboy pastimes as spitting from the top of the Cabot Tower or surreptitiously carrying pocketfuls of stones onto the suspension bridge and dropping them into the river, I began to explore.

A lone rank of three Georgian houses, surrounded by bomb sites, remained in Bridge Street; I gave them a good long stare from the balustrade of Bristol Bridge. The city docks were still active, the fruit, fish and flower markets operated from the pavements of Baldwin Street and Queen Charlotte Street, and the area later cleared for the Old Market underpass was intact, with its underground lavatories in the middle of the road, the Tatler showing its Continental films in Carey's Lane and dray horses clip-clopping up from the brewery in Jacob Street. Sometimes I would trouser the sixpence I'd been given as bus fare – a valuable increment of spending power – and walk the 4 miles into the city. Always fond of maps and addicted to shortcuts, I devised a personal route: from Fishponds, I took to the banks of a stream, redolent of sewage, that flowed into the Frome at the back of Eastville Park. I then followed the river along Fox Road and Wellington Road where, in the backwaters, great wobbling heaps of detergent foam accumulated. Small flecks occasionally detached and floated away on the wind.

Another errand that took us into the city were visits to my mother's sister, Auntie Winnie, who lived with Uncle Wally and our cousin Susan in Easton Road. Behind their house was a maze of little terraced streets – Seal Street, Lion Street, Eagle Street – where ferocious, heavily lipsticked housewives in pinnies and fleece-lined boots stood at their thresholds exchanging gossip. Children skipped or played hopscotch and terrifying, leg-humping dogs roamed the pavements. At the end of Auntie Winnie's garden we could climb down onto a plot of waste ground, where several houses in Seal Street had been demolished and the ground was carpeted with orange marigolds gone wild from the gardens. Here, Susan's pet tortoise, Monkey Business, was lost, being unexpectedly recovered, none the worse, several weeks

later. The demolitions in Seal Street were a foretaste, for Easton was to become a Comprehensive Redevelopment Area. By the mid-1960s, the tide of demolition lapped at Auntie Winnie's doorstep, and she was given notice that the city council intended to compulsorily purchase her house. She was offered £100 for the land, the council arguing, with unassailable logic, that since the house was to be demolished it was without value. Essentially, Auntie Winnie's home and property were confiscated by the authorities, with nominal compensation, and she became a council tenant. She was moved to a house in Greenbank and told that, in due time, she would be moved on again. Such was the megalomania of the city's planners that they spoke of replacing the entire housing stock, spreading out from the innermost suburbs in concentric rings of destruction.

Meanwhile, I had left school and begun my first job, as a 'vanguard' (i.e., driver's mate) for a linen hire company with a depot and laundry at Clay Hill Trading Estate, Fishponds. To a fifteen year old who'd known nothing but home and school, life was full of new impressions and the job was, in its way, an interesting one. For the first time, I came to know the city with real intimacy. My 'drops' took me to the premises of dozens of businesses and trades, including several that would soon vanish. Around Queen Square and The Grove were the offices of stevedores and other port trades; models of ships reposed in glass cases and photographs of maritime scenes and bygone vessels hung on the walls. Another call took us to Pountney's, alongside the railway at Fishponds, the last survivor of Bristol's pottery industry. It closed not long after I started working. Our company had a contract with the university, which was serviced as a Saturday morning overtime job. In a road that, these days, is closed to the public, stood the New Medical Building, the posthumous destination of those who leave their bodies to 'medical research'. Ranged along the corridors of the upper floors were cabinets of medical curiosities preserved in jars of formaldehyde. One was the head of an old man, cut open on the left side to disclose the interior. Apart from its caretaker, the building was empty at weekends and the rooms kept locked. Applying my eye to the keyhole of a door marked 'Dissecting Room' (a draught of refrigerated air made it water), I beheld the forms of sheeted cadavers laid out on slabs. Elsewhere was a cabinet of skulls, categorised by race – one, tiny and pathetic on the bottom shelf, was labelled 'The Head of a French Idiot'.

Most of all, I liked the panelled interiors, creaking floorboards, stair rods and antiquated lavatories of the eighteenth- and nineteenth-century buildings in Bristol's commercial district. Often, they had old-fashioned caged-in lifts; I became a considerable connoisseur and authority, able, by a glance at the polished brass fittings and ceramic floor buttons, to identify even the most obscure manufacturer. At the office of an architectural practice in Orchard Street, I was responsible for not only the delivery of our wares but also their distribution. Internally, the building had been united with its neighbours and I was proud of my ability to find my way around the labyrinthine, many-chambered interior – a conundrum that defeated our other roundsmen. Half an hour after entering, I emerged, breathless and blinking, several doors down the pavement from where I had started. Across the street, a man with white hair and half-moon specs – a casting director's idea of a 'craftsman' – worked with miniature tools to remove overpaintings from plasterwork on the stairs

of an eighteenth-century house. Each week, I noted, he was one step further down. In Queen Square, I sometimes paused on a dim landing to admire a framed battle scene commemorating the residency of the Polish patriot Tadeusz Kościuszko. I found myself becoming interested in buildings, particularly (though I am not so keen these days) in the architects of the Victorian commercial style known as 'Bristol Byzantine'.

By this time, it had become a common experience to turn a corner and discover that part of one's accustomed surroundings had become a wasteland of mud and trenches. Familiar streetscapes vanished overnight, leaving a disorientating aerial void. As we have seen in the cases of Newtown and Easton, entire districts of nineteenth-century terraced streets were destroyed and the inhabitants rehoused in tower blocks or on grim council estates. Often, the destruction was associated with road widenings or more elaborate schemes of 'improvement'. These new or widened roads sliced through existing frontages, exposing the unsightly backsides of neighbouring properties, spreading blight into their surroundings. These surroundings then became 'ripe for development'. As property values soared during the 1960s and 1970s, cranes appeared against the sky and, from behind temporary hoardings, reinforced concrete frameworks began to rise. The speculative office developments appeared along Rupert Street, Lewins Mead and elsewhere.

By the early 1970s, public scepticism about redevelopment, urban renewal and planning policy was becoming vocal. Finally, almost literally overnight, the public mood caught up with our legislators. One night in 1975, so it seemed, they went to bed convinced of the urgency and necessity of redevelopment; next morning, they threw back the sheets as passionate conservationists. Planners and architects suddenly looked around at their creation: they saw vandalised tower blocks, rain-streaked concrete, hooligan-frequented precincts, aggregate panels, defaced subways, dead expanses of tinted glass, nonsense sculpture and rain-lashed walkways. A veil fell from their eyes. 'What have we done?' they asked themselves. The matter was encapsulated for me when one day on the television I heard the architectural commentator and TV pundit Patrick Nuttgens vehemently deploring the damage done by post-war planning policy. The corners of my mouth turned down and a sour look creased my normally impassive features, as I remembered seeing him only a fortnight before advocating the cause of modern architecture, whose champion he had been for many years. Seldom had the feat of jumping from one bandwagon and leaping aboard another been so smoothly accomplished.

At about this time, the corruption scandal in the north-east involving T. Dan Smith and John Poulson came to light. In the close association that had developed between planners, local government bureaucrats, architects and property developers, it would be surprising if such practices had not become the norm. A few other cases did receive minor publicity. At a time when homelessness was often in the news, the property tycoon Harry Hyams attracted opprobrium by allowing his Centre Point building in London to stand empty, accruing millions in value and exempting it from local authority rates. 'High rise' immediately fell from favour when an entire corner of a block of flats, Ronan Point in East London, tumbled to the ground early one morning following a minor gas explosion. Opposition hardened. Suddenly, scaffolding appeared around previously condemned

buildings, and the renovators began moving in. It became almost impossible to demolish even very undistinguished premodern buildings, which were now clung to as something precious. 'Façading' came in, as developers were compelled to preserve street frontages and build low-rise structures. New uses were found for large derelict industrial structures.

However, it was too late; by this time, the townscapes of Britain had been ruined forever. It is an episode that has been largely forgotten. It was, I think, one of the great social disasters of our times. A couple of generations have grown up experiencing the visual poverty of their surroundings as normal. If they think about the matter at all, they probably blame it on war damage. The memories of their elders have faded. In the post-war years, far more destruction was done, far more unforgivably, to the fabric of cities, such as Bristol, by their own officials than was ever inflicted by the Luftwaffe.

In wartime, the authorities had granted themselves powers of regulation and compulsion that they were disinclined to relinquish in peace. In the post-war years came a spirit of idealism and an expectation of reform on egalitarian principles. This was the epoch of totalitarian social engineering schemes, such as the project to reduce London's population by 2 million and rehouse the 'overspill' on the periphery of existing towns and villages or in 'new towns' built from scratch. A telling moment came when Lewis Silkin, Minister of Town and Country Planning in the Attlee government, chaired a meeting in Stevenage Town Hall, where most of the population had turned out to demonstrate its hostility to the building nearby of the first new town. 'It's no good your jeering,'

New uses for large, former industrial buildings. The granary and flour mill at Buchanan's Wharf, built in 1884 was converted to flats in 1988. The gap between the buildings, resulting from war damage, has since been filled and all of this waterfront was smartened up and gentrified during the 1990s in an attempt to emulate London's docklands. The photograph was taken on Wednesday 23 July 1975.

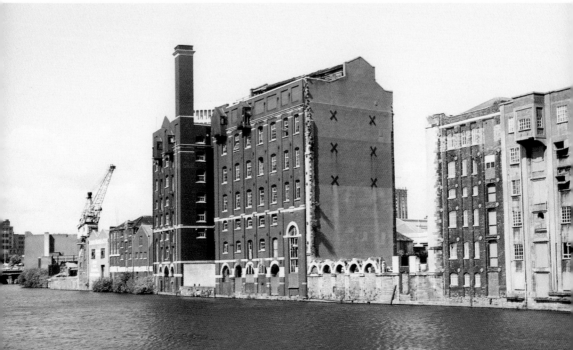

Silkin told the crowd, 'it's going to be done'. When it was done, he made a point of ensuring that the town hall was the first building to be demolished. It is difficult to avoid the conclusion that spite was an important element in all this. There was something in it of hatred for ordinary people and detestation of their natural attachment to familiar things. We got used to being told that 'Britain must be dragged [usually 'kicking and screaming'] into the twentieth century.' There was something sinister in terms such as 'overspill'; to people like Silkin, human beings were merely demographic profiles, traffic flows, population densities, taxpayers, human resources, producers, numbers. Perhaps one of the ways in which people could be made ready for the coming collectivist utopia was to destroy everything they knew. In George Orwell's *Nineteen Eighty-Four*, the annihilation of the past is one of the main instruments of control. People are far easier to manipulate if they are unable to compare the present with the past, and without a cultural or historical memory, they feel no allegiances.

Bristol was once a very particular city. It was (and still is) being remade as nowhere in particular, indistinguishable from cities anywhere. Modern architecture has no connection with any previous local, national or cultural tradition; not for nothing is it sometimes called 'the international style'. What cannot be swept away without opposition is emptied of meaning – sanitised and museumised with retro bollards, railings, hanging baskets, planters, brown 'heritage' signs, synthetic 'cobbles', 'Victorian' litter bins, interpretive signs and tourist information. What survives of the older parts of Bristol looks so relentlessly authentic that it can only be fake. One often has the feeling of walking onto the set of a TV adaption of Jane Austen.

Bristol was never esteemed a particular beauty among English cities, yet, as first acquaintanceship warms into familiarity, her confidences become more intimate and she slowly reveals her allurements. Alas, the brushstrokes of this 'portrait' cruelly exaggerate certain of her less attractive features. I would not wish the reader to think that I had set out to produce a hatchet job; it was in the nature of the times and the subject matter that some unflattering aspects of the city should be overemphasised. We all form a bond with, and have a special regard for, our native place; we are never entirely happy away from it. The historical context and physical surroundings into which we are born and among which we grow up, we come to regard as natural and 'correct'. We experience subsequent departures from this condition as a loss. Over the course of a lifetime, these small losses build into a calamitous deprivation. Our sense of loss ossifies into a complete world view. As we grow older, we think things are not as good as they used to be. This is one of the constants of human experience to which few are immune. This time around, are we right? Is the change in our surroundings or in us? Change, they say, is the only evidence of life, and obviously Bristol has changed, as every city has. What it boils down to is whether the change is for the better or worse. If you seek the answer to that question, simply browse through one of the many books of photographs of Victorian and Edwardian street scenes. Then just look out of the window.

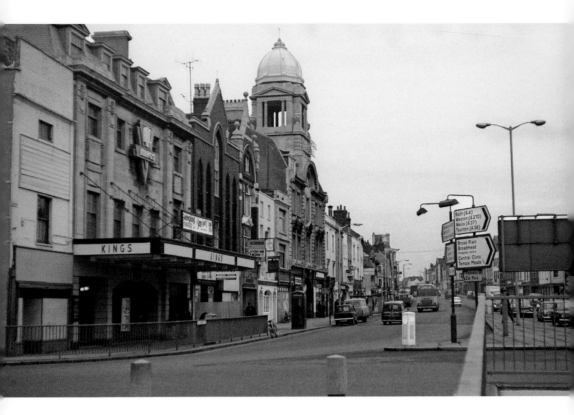

Old Market Street, seen on Friday 28 December 1973. The King's Cinema belonged to the ABC group which, in Bristol, included the Whiteladies, Rex (Bedminster), New Bristol Centre and Vandyck (Fishponds). I sometimes bought a copy of the in-house magazine, the *Film Review*. Its contents were mostly articles and photographs plugging films soon to be released through the ABC chain. It was advertising you paid for. A cognate publication, Showtime, was sold at Rank cinemas. Like all the businesses in Old Market Street, the King's suffered when it was cut off from the rest of Bristol's commercial district by the Inner Circuit Road and its underpass. The whole area went into a slow decline and has remained proof against all attempts to revive it. The cinema was already known to be due for closure. The Punch Bowl public house remains open for the time being, but the other properties up to the central hall are condemned and boarded up. Today, all but the King's survive, probably saved by the mid-1970s conservation backlash.

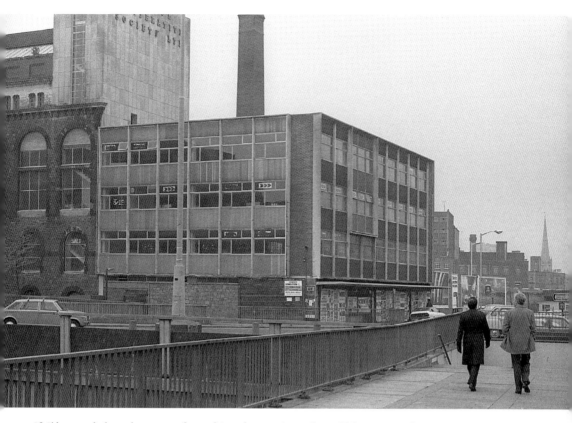

If I'd turned the other way after taking the previous shot, I'd have seen this. Many post-war buildings had short lives and passed unlamented. Who now remembers the Dolphin public house in the Broadmead Shopping Centre, demolished as early as 1961 for Marks & Spencer to extend to the corner of Whippington Court? Constructed as offices for the Co-op, this building first stood in the middle of a rank, but one day, as the area was cleared for the Old Market underpass, found itself exposed on a corner. The Bristol Omnibus Co., displaced from its premises in Carey's Lane, moved into the building and dubbed it Old Market House. The area was no longer the important hub it had been in tram days, and when, in August 1970, its lease expired, the company decided to move out of Old Market altogether. Crew-relief facilities were dispersed to other points around the city. The resultant changes to crews' duties caused a four-day strike. A number of short-lease tenants traded from the ground floor in the years that followed, but on Friday 2 May 1980, the building was empty and came down shortly afterwards.

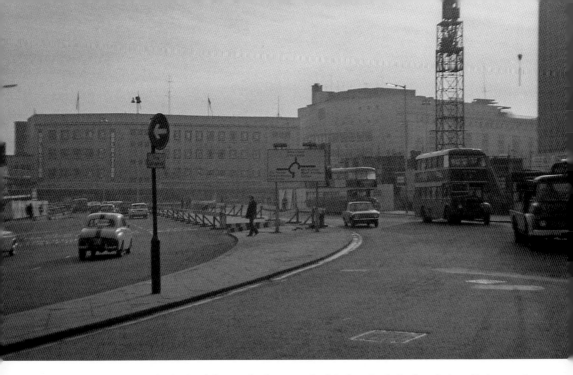

Above: Many people think of this as the lower end of Stokes Croft. In fact, it is a distinct entity, North Street, and we are looking across to the former Jones & Co. store – already, I think, absorbed into the Debenhams chain – where, on Tuesday 16 January 1973, the post-Christmas sales are in full swing. Widening and enlargement of the St James Barton roundabout had already caused the destruction of a small Georgian square off to the left. This view was shortly to be blotted out by construction of Avon House North, which spanned the road at this point. Preparations are already in hand. The tall building at the right edge is Avon House, due, in April of the following year, to become the headquarters of the preposterous and mercifully short-lived county of Avon. Somehow, people got it into their heads that the name should be pronounced like that of the cosmetics company – I winced every time I heard it said in this way. On the opposite side of the street, a roll call of lost British marques: Standard, Singer, Bedford, Triumph, Morris.

Opposite below: A year later, on Wednesday 17 April 1974, the work of demolishing the CWS building had just resumed. The Garrick's Head pub, an exuberant design of 1902 by Edward Gabriel, was to come down in November 1978 for an extension (now demolished) to the Bristol & West Building Society's offices. In its latter years, it had the reputation of catering to a largely 'gay' clientèle. The CWS was slightly later, of 1905–06 by F. E. L. Harries. Approaching from Prince Street is one of Bristol Corporation's handsome silver ambulances.

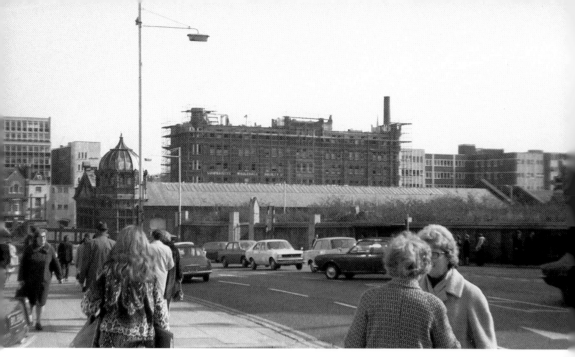

Above: Lunch-hour bustle on College Green, Wednesday 7 March 1973. The clock tower and upper floors of the mighty Co-operative Wholesale Society (CWS) building had gone, but demolition had come to a standstill and did not resume until April of the following year. It was completed in October 1974, but the site remained empty until 1980. The long building in the middle distance was only a disused quayside shed; the modish shops and restaurants of the Watershed were some years off. A hold-up begins to form as traffic bound for Park Street pauses to let a car out from Deanery Road. A mini-roundabout appeared during the last years before Deanery Road was pedestrianised and its traffic rerouted along Anchor Road. Across the street is the churchyard of St Augustine-the-Less (the cathedral is St Augustine-the-Great), which had been demolished in 1962. The burial ground remained an entanglement of brambles and buddleia until an extension of the Royal Hotel came in the 1990s. Perhaps the two ladies in the foreground belonged to that tribe of female administrators who, in those days, were a formidable influence in the lives of offices, reducing many a young typist or office junior to quivering terror. Were they from one of the long-established businesses in and around Park Street – Perez, Newberry & Spindler, the Pied Piper Bookshop, Churchill's, Bauers the furriers – or perhaps the Royal Workshops for the Blind, the Folk House or the Masonic Hall? Nowadays, even Chilcott the jeweller is gone, and of the old shops, I think only the Bristol Guild of Handicraft remains.

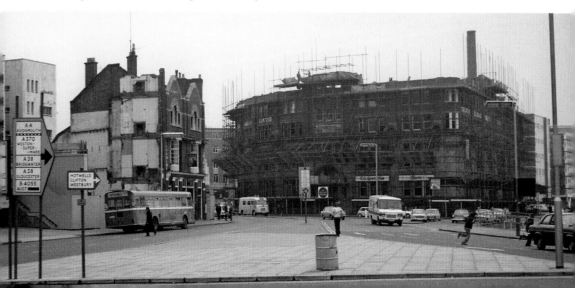

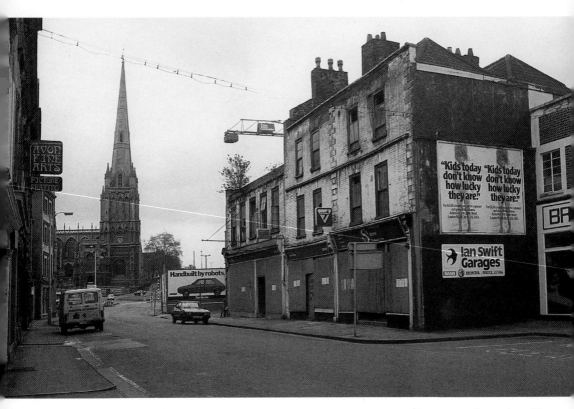

Today, it is difficult to grasp that this shabby backwater was once Bristol's main north–south traffic artery. I sometimes try to imagine what it must have been like in, say, the early part of the past century, before the coming of the motor car and the obliteration of ancient patterns of traffic flow; the great steeple swinging into view as you proceeded south from Bristol Bridge, shops and houses clustered around the church, Redcliffe Hill groaning with trams, Bedminster's tobacco factories, busy shops lining the entire way, the smell of dung, the creak of the market woman's cart and a lovely whiff of coal smoke from a passing Sentinel – the ominous harbinger of the motor age. Lively street life and variety for the eye everywhere you look.

Well, just look at it on Easter Monday, 20 April 1981. The blight must have set in when the earliest part of the Inner Circuit Road was laid down, forming Temple Way, Redcliffe Way and the dual carriageway (now removed) across Queen Square. Work had begun before the war. Council flats massed around the great church, giving its precincts a faint look of Khrushchev-era coke-sorters' communal housing on the outskirts of Magnitogorsk. A roundabout, with its shaven grass and cheerless beds of primula, was laid down at the foot of the steeple, and every building was demolished on Redcliffe Hill, which was doubled in width. Thank you so much.

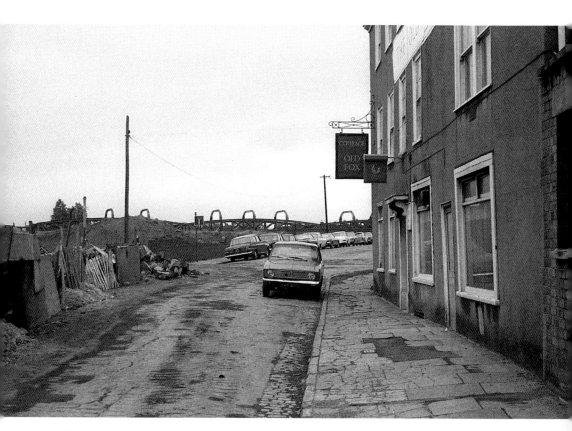

The Old Fox, in Fox Road, Eastville, occupied an honourable place in the history of the 'Real Ale' movement, which took off in the early 1970s as a reaction to the tyranny of gas-pressured 'keg' beers supplied, more or less compulsorily, by the big brewing conglomerates. CAMRA – the Campaign for Real Ale – set up a company to buy and operate pubs specialising in real ales. The Old Fox was the first it acquired. It closed in 2004, probably a victim of the success it helped create: now that we can buy a good range of bottle-conditioned ales at a supermarket, the beer aficionado no longer has to travel to a remote backstreet boozer when he fancies a decent jar. The photograph was taken on Wednesday 10 July 1974, just before the CAMRA takeover, when the pub was still a Courage House. The proportions of the windows at this end suggest a nineteenth-century extension. The iron railway bridge spanning Stapleton Road and the River Frome was dismantled in 2017. At the end of the eighteenth century, the pub had catered to bathers, but the river was diverted into a culvert beneath the M32 motorway around the time of the photograph.

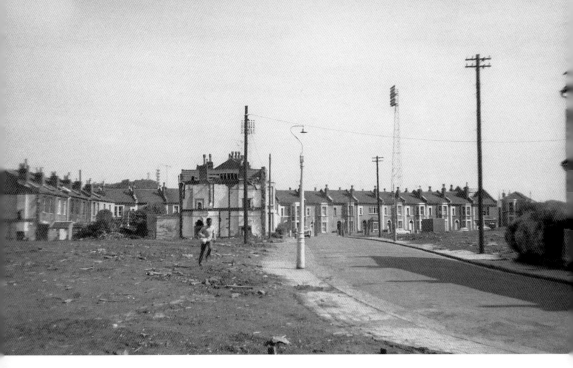

Above: Looking along Redding Road to Napier Road, Eastville, Wednesday 29 July 1970. The foreground had been cleared for the elevated part of what was then called The Parkway, now the M32. The floodlights belonged to Eastville Stadium – the Rovers Ground – now the site of an IKEA store. Over the rooftops on the left horizon, we can see the new telecommunications tower on Purdown, but its latticework predecessor lingers on. Completion of the motorway 'corridor' into the centre of Bristol seemed to take years. All the houses on the north side of Stapleton Road had been cleared from here to Muller Road, where the splendid curved railway viaduct had been felled as long ago as 1968. Once the motorway was open to Lower Ashley Road, a dual carriageway extension had to be constructed to take traffic on into the city. This dwindled away into Newfoundland Street, an ordinary two-lane backstreet. It was well into the 1980s before this was adequately widened.

Opposite below: Ten years after the previous photograph, on Thursday 9 April 1981, the cleared land is still vacant and has been turned over to car parking. A full day costs 75p. I think the photograph was taken from the doorway of Transport House, the Transport and General Workers' Union's regional headquarters. Looking along Cart Lane, where a Mk IV Ford Cortina is parked on the corner, the distant 1960s block, Templar House, on Temple Way, was living on borrowed time. Eventually, a Novotel was built here. Cart Lane survives as a footway, but on a slightly different alignment.

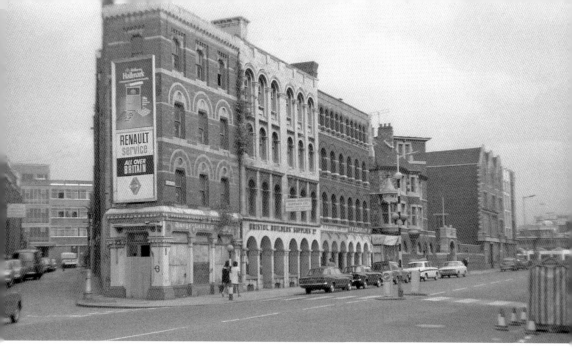

Above: When Victoria Street was laid down in the 1870s it smashed through the medieval street plan of the Temple district, producing several of these sharply angled junctions with 'flat-iron' plots at the corners. The street suffered badly during the war, and what the Luftwaffe left unfinished the city council completed. Today, only the rank between Bristol Bridge and Counterslip survives to convey something of the street's original appearance. Photographed on Monday 12 July 1971, these buildings eventually came down around November 1973. Beyond the first three properties is Temple Colston School, a work of Foster and Wood, architects of the Colston Hall, the Grand Hotel and much else of Bristol's Victorian fabric. It comes as a surprise to see that traffic cones were already with us in 1971.

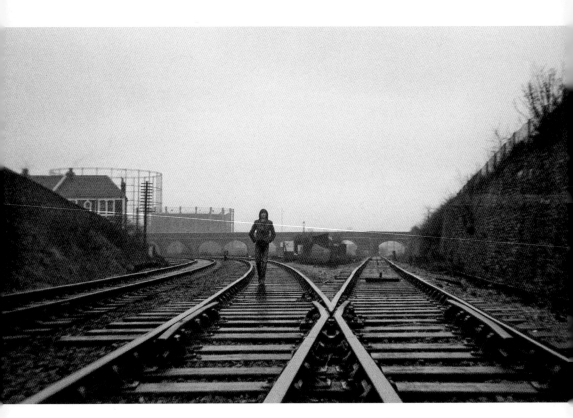

A voyage around The Dings, Sunday 11 January 1970. Forty or fifty years ago, there was nothing quite like an English Sunday afternoon, on a dismal day of midwinter, to induce that sense of mingled dejection, sloth and boredom that, as 'angst', was later to become such a fashionable state of mind. A friend and I had walked 4 miles to St Philip's to enjoy this masochistic experience. I regret to record that we were inveterate trespassers on railway property. Here, he is seen walking along the northbound side of what had, until a few weeks earlier, been the main line to Birmingham. It had closed at the beginning of the year and its traffic permanently diverted via Filton. Here, the tracks had spread out fanwise through the arches in the middle distance to enter the engine sheds at Barrow Road. The sheds were closed and demolished in 1965, leaving a vast expanse of waste ground. It became another of my brooding places. At the approach of winter evening, as strands of mist formed a few feet above the ground, the jangle of shunting – a lovely musical sound now lost to the world – drifted over the rooftops from Lawrence Hill, acquiring an added plangency as it echoed among the storage tanks of the gasworks.

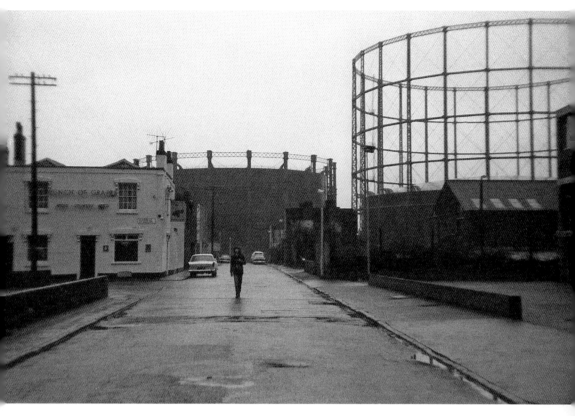

'There is no excellent beauty that hath not some strangeness in the proportion.' The area around Sussex Street was busy during the week, but deserted on Sundays. During my first job, I sometimes worked on a van round serving this district. The driver was called Harry. We progressed around the pot-holed streets, where the paving stones had been shattered and flattened by the wheels of cornering lorries. Our customers were an assortment of tanneries, wastepaper reclaimers, scrap dealers, a council yard and various companies in the metal trades. There were many small engineering workshops where, among the barrier cream dispensers and ever-whirring lathes, I trod carefully to avoid razor-sharp shavings of metal that became embedded in the soles of my shoes and were, I now learned, called 'swarf'. The walls were decorated with 'topless' photographs from the pages of *Parade* or *Health & Efficiency*. The round was unpopular with my fellow roundsmen, among whom was known as 'Harry's Depresser'. I rather enjoyed it. The Bunch of Grapes, on the left of the photograph, was not among our customers, but Harry had a fiddle going with the landlord. The pub thrived on lunchtime trade from the surrounding businesses. An 'autoroll' towel cabinet in the pub's kitchen had been overlooked and left in situ by former a supplier. It was understood that if we provided a clean roll for this cabinet (a visiting food hygiene inspector had commended the landlord for installing it), we would be given a free lunch. To Harry, struggling to maintain a council flat, wife and young children on £14 per week, the free meal came as a welcome perquisite.

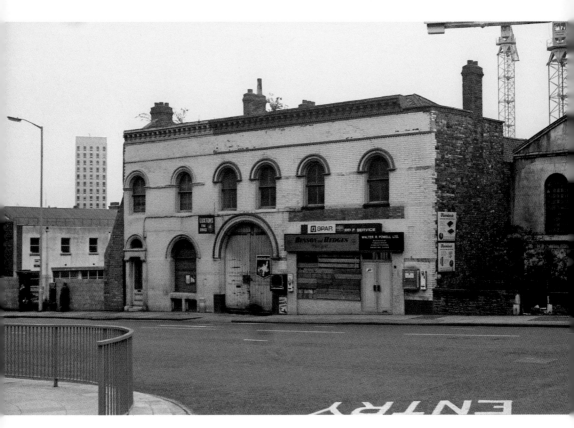

It looks as though the architect went to considerable trouble to make his brickwork attractive, so it's a pity the owners felt the need to paint over it, particularly as they couldn't agree on a common colour scheme. Even so, the fancy cornice and cog-tooth moulding of these humble but decent buildings in Upper Maudlin Street were very enjoyable. On Saturday 20 April 1974, newsagent and tobacconist Walter J. Powell had recently closed, leaving behind two chewing-gum- and two cigarette-dispensing machines. Luxton's Tyre Service was still trading at the rear of the premises, reached by the arched entrance. The cranes are building the Greyfriars offices in Lewins Mead. Visible on the right is the Welsh Baptist chapel of 1840. It had struggled on, with services entirely in Welsh, until 1964 and was demolished in January 1979.

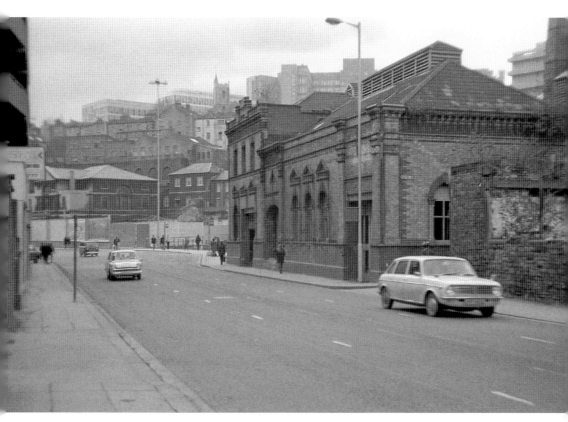

With work on the Inner Circuit Road suspended during hostilities, the first post-war section, Bond Street, was contemporary with the Broadmead Shopping Centre. For years, Bond Street fizzled out into Carey's Lane and Haberfield Street and didn't come into its own until the Old Market underpass linked it to Temple Way. The 'circuit' was finally closed, around 1970, by constructing this three-lane, one-way street roughly on the alignment of Lewins Mead. The original street of that name, a cobbled backwater of little workshops and factories reached by alleys and flights of steps, was completely obliterated. At the same time, Rupert Street became one-way in the opposite direction – the two streets were, in effect, the opposing sides of a dual carriageway. A few of Lewins Mead's original buildings lingered on for a time, until the coming of the Greyfriars office development and an extra lane for bus stops. I think this building was one of those put up in 1887 for United Bristol Breweries, mostly destroyed in bombing. The Rupert Street multistorey car park (part of which is seen, top left) came to occupy the greater part of the site. The brewery's buildings were designed by William Bruce Gingell. The Crown & Dove Hotel (see next photograph) must have been one of them. The building seen here was heavily pockmarked by bomb fragments and had been further disfigured by crudely inserted vehicular entrances. It is difficult to imagine any thoroughfare today being given so down-to-earth a name as Gravel Street, which was the little turning behind the closest car. The photograph was taken on Saturday 24 February 1973. The building came down in April.

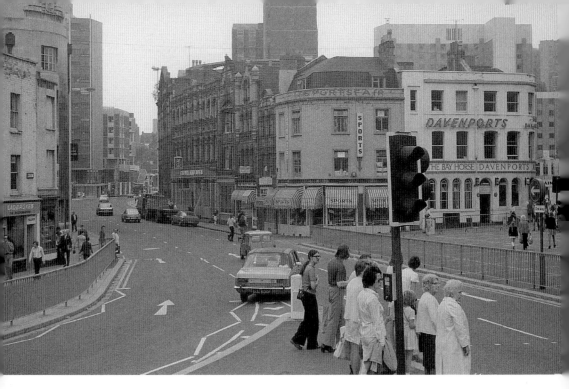

Above: Looking along Rupert Street, Thursday 22 August 1974. The Crown & Dove had pulled its last pint two days before, and lorries are parked at the kerb, removing the stock and fittings. The building known as One Bridewell Street now stands on the site. The two properties beyond the sports shop survive today – the last remnant of W. B. Gingell's brewery complex of 1887. Gingell loved the juxtaposition of yellowish bricks with red terracotta ornamentation. Alone, or in partnership with T. R. Lysaght, he was responsible for many of Bristol's best-known Victorian buildings. Today, the ground floor of the Bay Horse pub has been remodelled, and the paved area in front is planted with trees and divided by a bus lane.

Opposite below: The same view on Saturday 17 May 1980. For another year or two, the old houses will remain exposed. The magistrates' court is open for business and speculative office development has obliterated what little remained of the old Lewins Mead. Behind the traffic light may be discerned flights of steps (since resited), where the ravine of concrete is bridged by a pedestrian walkway. It was an ambition of the city's planners to separate pedestrians from motor traffic. Cars could stay on the ground, but human beings would have to go up in the air and keep out of the way. A complete network of these walkways was envisaged and were to be provided as part of any new development. Unfortunately, people obstinately persisted in their habit of using the pavements on either side of the street. Puddled, wind-lashed fragments of the scheme survive around John Street and Lower Castle Street. Froomsgate House has been remodelled in recent years and been raised by two storeys.

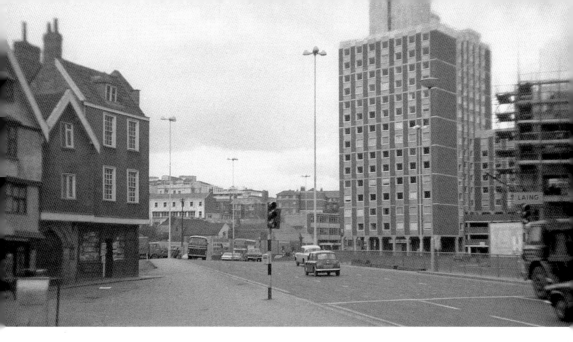

Above: The widening and straightening of Lewins Mead had involved smashing a path through Christmas Street, which had run from the foot of Christmas Steps to the arch beneath St John-on-the-Wall. The council thought that, while they were at it, it would be a good idea to demolish the buildings facing the foot of Christmas Steps, so that the picturesque timber-framed houses would be exposed to the gaze of motorists hurtling past in the three-lane torrent of traffic. The newly visible houses were then renovated so that they no longer retained any appearance of antiquity. At this point, someone tactlessly pointed out that the proper setting for 'jettied' houses with projecting upper storeys was a narrow medieval street. It was, therefore, decided to re-enclose the foot of Christmas Steps, as though this made everything all right again. The problem, of course, is that once you have demolished 400-year-old buildings you can only replace them with new ones, and in the second half of the twentieth century, we all knew what that meant. On Saturday 24 February 1973, Froomsgate House is newly complete and John Laing have made a start on the new magistrates' court, now demolished.

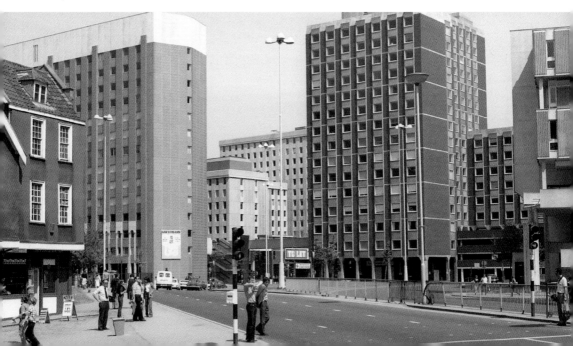

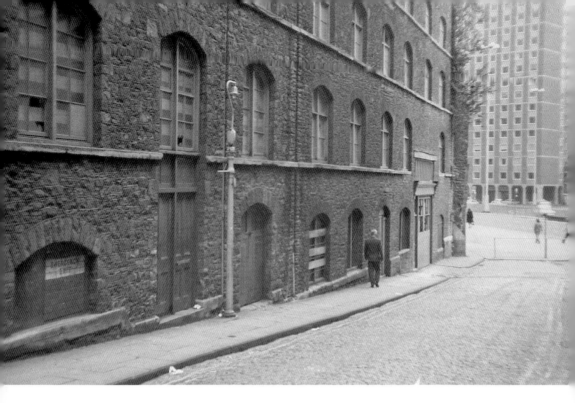

Above: Looking down Host Street towards Lewins Mead, Thursday 28 June 1973. Not long before, a bus driver, then nearing retirement, had told me that these buildings had once been stables for the horse buses. When the foot of Christmas Steps was re-enclosed, the far end of the building, beyond the walking figure, was demolished to provide a car-turning circle, perennially jammed with Churngold wheelie bins. The lamp would have been a gaslight converted by the addition of a swan-neck bracket.

Opposite above: With the completion of their pet project, the Inner Circuit Road, life must have seemed a bit flat for the boffins in the council's planning department. Somehow, you don't feel as important when drafting the grass verges and flowerbeds (Specifications and Miscellaneous Provisions) legislation. Then somebody must have had a bright idea: what if we were to have an Outer Circuit Road as well? The drawing boards and T-squares came out again, and plans were put in hand. There was to be a huge new interchange at the Three Lamps junction between the new road and the Bath and Wells roads. This would involve demolishing half a square mile of terraced streets, uprooting hundreds of families and forever burying the lower part of Totterdown under concrete and asphalt. In the photo, taken on Wednesday 7 March 1973, the A4 Bath Road curves away to the left, staying level as it follows the valley of the River Avon, and the A37 to Wells begins its climb out of the city. I had hoped to get a picture of the famous turnpike fingerpost that had stood at the junction, but discovered it had been removed two days before. A hole fenced off with barriers and lamps marks its former position. It spent the next decade in a council depot at Lockleaze, where it could be seen from passing trains. The little flat-iron building on the corner was knocked down a week or two later.

Opposite below: A view from outside the Bush public house looking down Wells Road towards the Three Lamps junction. A year or two before, these pavements would have been thronged with shoppers. Already, gaps have appeared on either side of the road, and those shops that remain are boarded up ready for demolition. By June, they were all gone and so was the lively community they had once served. The area has never recovered its vitality.

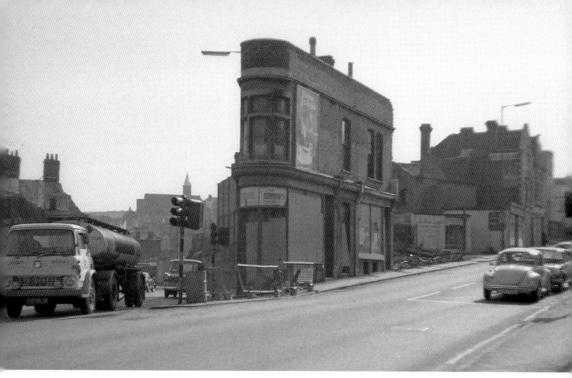

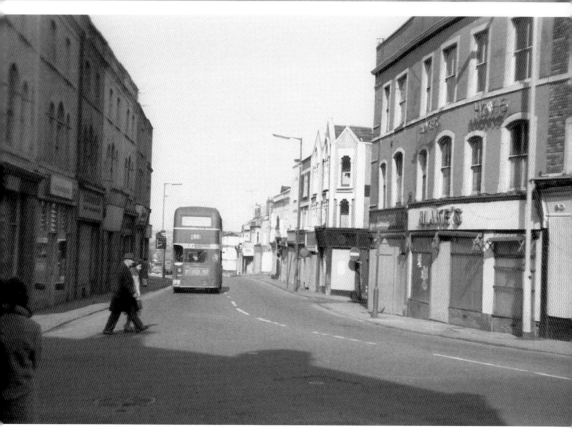

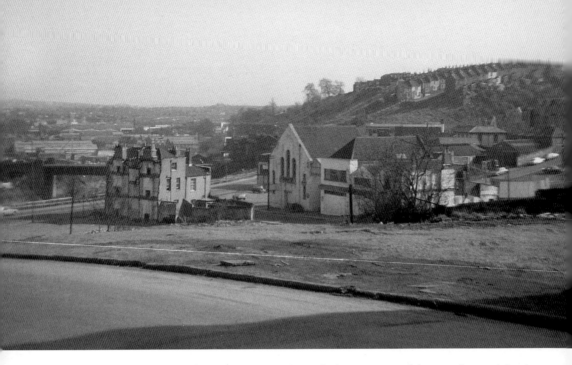

Above: Looking from Wells Road down to Bath Road, showing part of the area flattened for the planned Three Lamps road interchange. In the foreground is the surface of New Walls Road. A cluster of doomed buildings, including a Methodist chapel, is grouped around the foot of Angers Road. Totterdown Bridge spans the still tidal Avon at the left edge. The little streets of closely packed houses on their steep valley-side site, a unique piece of townscape, had gone and could never be replaced.

Opposite above: Here, we are looking back to the Three Lamps along Bath Road, with the former Blue Bowl pub on the right. The Outer Circuit Road was to have ringed the inner suburbs from here by way of Bedminster, crossing the New Cut and Floating Harbour to another multi-level scheme at the bottom of Jacobs Wells Road and interchanges with Whiteladies Road, Gloucester Road, the M32 and Lawrence Hill. None of this ever took place. The only part of the road ever built was that between the M32 and Lawrence Hill, already constructed as part of the Easton comprehensive redevelopment scheme. Years later, it was extended south to link with the Bath Road at Arnos Court. Today, albeit that the road is about three times the width we see here, the Three Lamps is still a conventional junction controlled by traffic lights. The congestion that forms here – I write from experience – is no worse than it was in 1973. Congestion tends to be self-regulating, like supermarket checkout queues. The destruction of the lower part of Totterdown was perhaps the greatest atrocity of the city council against its citizens.

Opposite below: Station Approach (popularly 'Temple Meads Incline') seen from the short-lived footbridge across Temple Gate on Monday 7 April 1975. It had been erected in October the previous year and was dismantled in a later revamp of traffic lights and pedestrian crossings. Behind the camera, the footbridge entered a newly constructed building, and pedestrians could descend to the pavement by escalator or pass through to a car park.

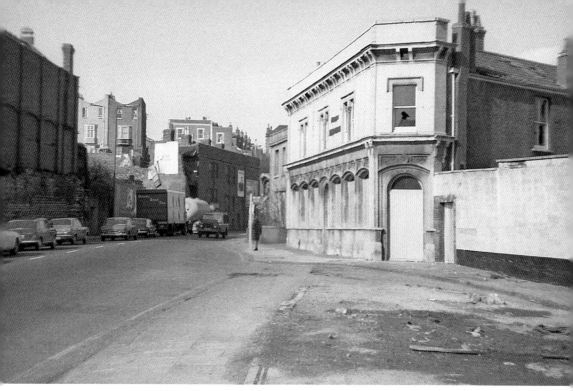

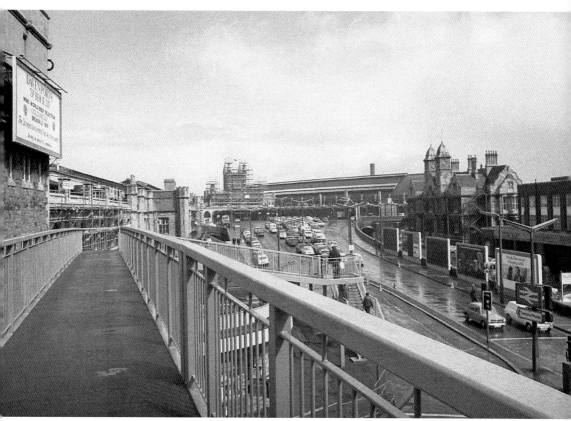

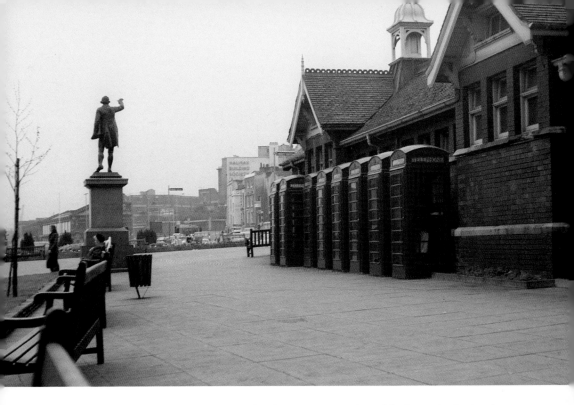

Above: An agreeable row of telephone kiosks snug against the public lavatories in the city centre, Wednesday 17 April 1974. The conveniences went in December, to be replaced by new facilities on Colston Avenue. Demolition of the toilets led to relocation of the kiosks, approximately in the position occupied in the photo by the benches. British Telecom – or was it still the GPO in those days? – hated the 'iconic' K6 kiosk, designed by Giles Gilbert Scott, and didn't miss the opportunity of replacing these with the current, more functional, K8 design. All but the Edmund Burke statue disappeared during the 1990s, when the municipal flowerbeds were revamped according to the very latest ideas in urban design.

Opposie above: The Holms Sand & Gravel Co. must have been the last commercial users of the Bathurst Basin, as they were to be of the city docks as a whole. The firm dredged sand (and gravel) from the bed of the Bristol Channel, close to the islands of Flat Holm and Steep Holm. Inexhaustible supplies were freshly deposited each day by the world's second-greatest tides. The photograph was taken on Sunday 3 August 1975, a day of appalling 90-degree heat, during the most torrid month of that outrageous summer. The firm moved to a wharf off Hotwell Road (popularly Hotwells Road) for the next fifteen years or so, eventually abandoning the city docks altogether. It was unfortunate that high tide so often coincided with the morning or evening rush hour, so that the Cumberland Basin swing bridge had to be opened, causing traffic jams all the way back to the city centre.

Opposite below: A short distance away, another of the Holms company's 'sand boats' is berthed at a wharf below Bristol Bridge. In the distance, the flour mills and granaries of Buchanan's Wharf await their 1990s refurbishment as 'yuppie' fla... sorry, apartments. The categorising, regulating, order-obsessed minds of planners detested 'mixed use' and sought the separate zoning of industrial and residential property. Although the smart young professional people who came to live here probably liked the idea of a gritty, edgy, industrial ambience, they probably weren't too keen on the real thing. Besides, the city centre land occupied by these untidy cranes and heaps of sand must have been very valuable in terms of rental square footage. The sand trade had to go.

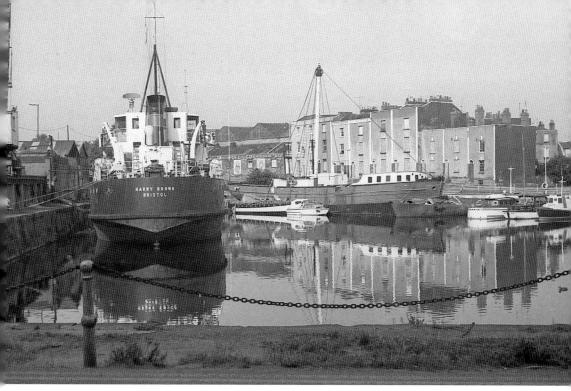

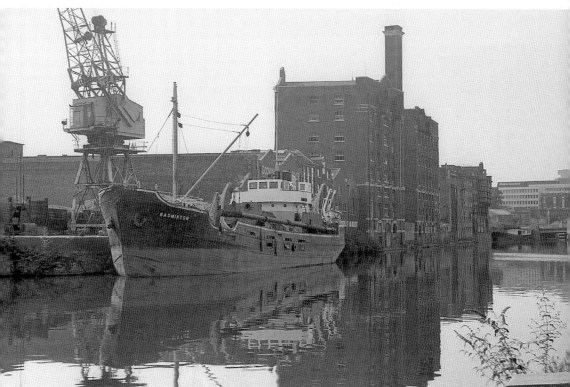

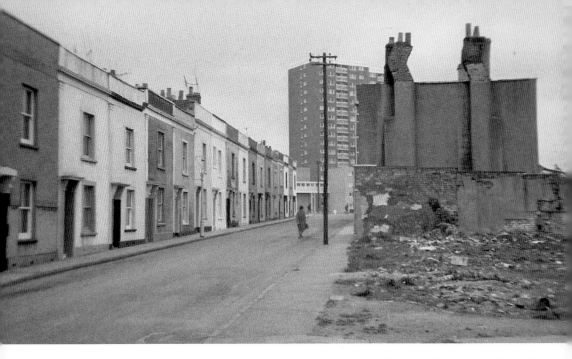

Above: In the 1960s and 1970s, we first began to hear of the 'problem of the inner city'. I doubt whether it had occurred to many people beforehand that there was one, but after being reminded of it repeatedly, they were nicely conditioned to accept the solution: 'comprehensive redevelopment'. Here we see examples of what was to be destroyed and what was to replace it. As far as Bristol was concerned, the inner city meant the older suburbs to the east, mainly Easton, St Paul's and St Philip's. These houses were rundown and in need of modernisation; whether it was true, as we were told, that renovation was more expensive than rebuilding, I don't know. Local people in the building trade would have been busy with useful work, but there wouldn't have been the profitable contracts for construction firms, architects, property developers, hauliers, waste-disposal companies and demolition contractors. And, who can doubt, no sweeteners and backhanders for the people who awarded the contracts. I was told by a man who had worked all his life in the road haulage business that you could, in those days, buy your way in for £10,000. After placing such a sum in the appropriate hands, you were assured of lucrative council contracts. The photograph shows Gladstone Street, Easton, on Friday 1 May 1970.

Opposite below: The Midland Inn looked quite a substantial affair for such a backwater as Midland Road, St Philip's. Like the nearby Palace Hotel at the top of Old Market Street, it must have been built on high hopes of trade from the Midland Railway's St Philip's terminus across the road. In the event, the Midland Railway quickly negotiated running rights into Temple Meads, and the St Philip's station was literally sidetracked. It lingered on until closure in 1953. This didn't look a typical Bristol pub to me: it seemed to bring a whiff of the Midlands down the line from Birmingham or Derby. It was photographed on Sunday 29 November 1981 and was demolished in 1998. The model of car parked at the kerb was known in certain parts of Bristol as a 'Vauxhall Veevle'.

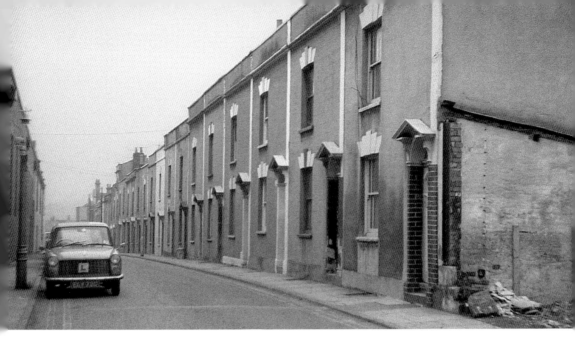

Above: Before the age of redevelopment, Easton consisted largely of streets of rendered, pavement-edge houses with little parapets, giving them a flat-topped appearance though in fact they had shallow pitched roofs. The little classical pediments above the doors would take us back to the earlier part of the nineteenth century, before Gothic came in. It's an ill wind that blows nobody good and one advantage of redevelopment was that, for we boys, there were always plenty of empty houses to explore and play in. They often stood empty for years. Poignant momentos of the last occupants – saucers, mildewed books and the like – lay around on shelves and windowsills. In the back gardens, buddleia and nettles prospered among lean-to kitchens and outdoor lavatories. We are looking towards Stapleton Road along Thrissell Street, on Thursday 24 February 1972, with the Thrissell Engineering Co. on the left. The houses were demolished in August 1974 and Easton Leisure Centre came on their site.

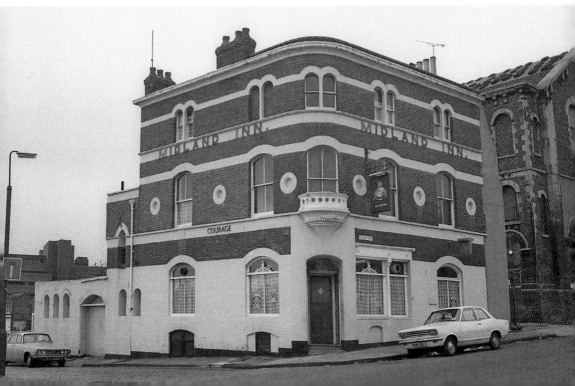

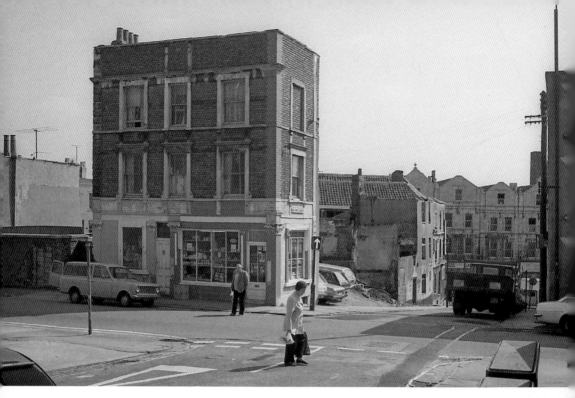

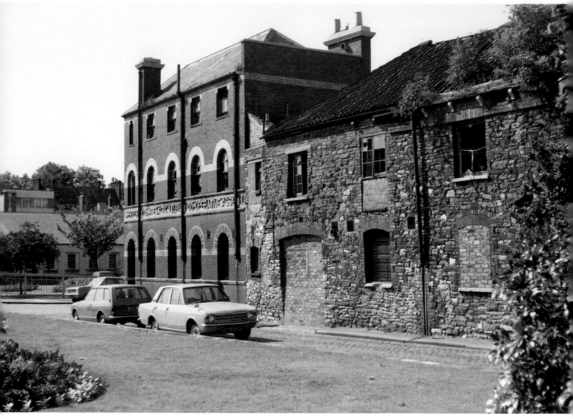

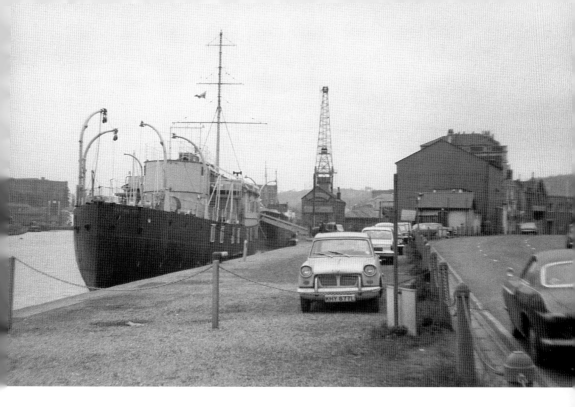

Above: The training ship HMS *Flying Fox* was, for many years, a familiar sight as one drove out of Bristol along Hotwell Road. She had been built in 1916 as a Class 24 sloop and was converted to a headquarter's ship in 1923. On the occasion of the photograph, Saturday 3 March 1973, muffled hammer blows came from within and smoke, from welding, issued from one of the lower portholes. The vessel was being made seaworthy for her final voyage across the Bristol Channel to a breaker in Newport. She departed on 18 March.

Opposite above: Hillgrove Street, Kingsdown, looking down to Stokes Croft, with Jamaica Street crossing left to right, Thursday 9 April 1981. The building facing us at the foot of the hill was demolished not long afterwards. Its replacement replicated the roofline, but in brick and a storey lower. The building in the foreground remains, but beyond, where the cars are parked, a modern block now stands, masquerading as a Victorian bay-windowed villa. The property on the distant corner has been renovated to the point of reconstruction. This became part of a conservation area: patchy render, flaking paint, trampled plots of ground used for car parking, blocked-up windows and mysterious fragments of walls surviving from otherwise vanished buildings are no longer tolerated here.

Opposite below: The post-war redevelopment mania foundered so abruptly that you could almost pin down the moment at which it occurred. One day you might condemn another inner-city Georgian terrace, but the next you couldn't even demolish a red-brick Victorian office in a back street down by the docks, such as the corner building in this photograph. It had been the office of the Western Counties Agricultural Co-operative Association, whose name is picked out in the stonework above the ground floor. Built 1896–97 to a design of William Venn Gough, but negligible as architecture, it was now prized as though a civic showpiece. The façade survives today with a new building inserted behind. Almost more interesting is the structure to the right. Buildings like this, in whose rubblestone walls could be traced the entire geology of the Bristol region, contributed much to the look of the city's lesser thoroughfares. Stone-setted Freshford Lane is now a bollard-impeded pavement.

It could be anywhere in that land of creosote and pebble-dash that is the interwar suburbs; in fact, we are in Gloucester Road, Soundwell, on Thursday 14 March 1974. The lane behind the houses is still lighted by gas. It is cheaper to leave the small remaining number of gaslights burning around the clock than to employ a lamplighter. We will not deceive ourselves that vandalism was unknown in those days, but it is likely that the lamps had been given protective cages as a defence against mischievous stone-throwing boys. Spring is coming on and the evenings are drawing out. School is over and the paper boy is on his round, delivering that day's edition of the *Evening Post*. The soul floods with peace.

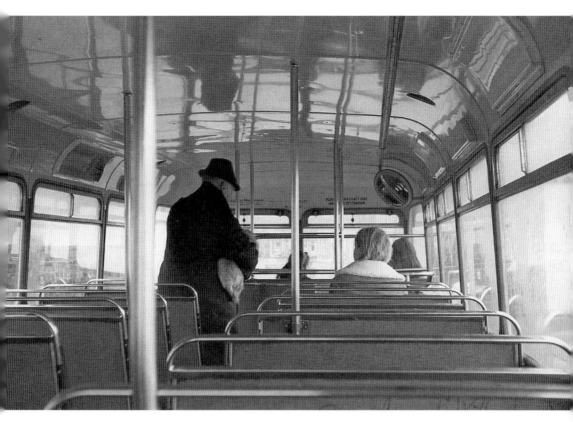

Getting around by bus. In common with other bus undertakings, the Bristol Omnibus Co. suffered a decline in its fortunes, starting from the mid-1950s when car ownership became an aspiration of the many. In an era of full employment, its problems were increased by a crippling shortage of staff. The photograph was taken on Monday 7 January 1974 on the top deck of a bus somewhere between Ridgeway Road, Fishponds and Staple Hill. Smoking had always been permitted on the upper decks of buses, but on this vehicle – a late example of its type – stubbers are no longer provided on the backs of the seats. Dogs were not permitted downstairs. That evening, following the first of a new series of Colditz and ahead of the enforced 10.30 p.m. closedown, Barbara Edwards appeared as television's first female weather forecaster.

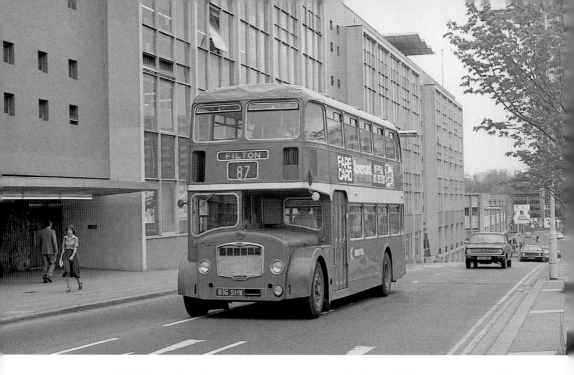

Mention of Colditz makes this an appropriate point at which to include a photograph of Fairfax House, the Co-op's escape-proof department store. It is a matter of regret to me that, in the few photographs I took of the building, it appears only as a background. Rather unfairly, people remember it for its confusing internal layout. Once you'd entered and circulated around its split-level interior, it was no easy matter to find a way out again. The downhill slope we see here is really the valley-side of the River Frome, which flows in a culvert beneath Broad Weir and Fairfax Street. Ground level sloped from one end of the building to the other and very steeply from side to side. This meant that the floors had to be staggered in both directions. You entered from Fairfax Street, ascended two floors and emerged, still at ground level, in Union Street. It must have been a difficult assignment for the architect, who, nonetheless, produced an elegant design and a building of excellent quality. To increase his difficulties, a vehicular entrance had to be provided from Newgate to a multistorey car park behind the Broadmead shops. It passed through the building to emerge on the far side – such was the drop in ground level – in an enclosed bridge across Fairfax Street. Among the store's novel features were the Paternoster lifts, which had no doors and didn't stop at the floors; you simply stepped in as they passed. As children, we thought this wonderful. A modern health and safety inspector would have to be revived with smelling salts. Even then, I think I had misgivings about the possible consequences of trapping your fingers or coat tails. The up and down lifts were side by side and were obviously on some sort of continuous belt. A friend and I conceived the idea that the cabins must pass over a pulley at the top and turn upside down. We decided to put this theory to the test. We stepped aboard and rose up through the building, discovering that there was a 'staff only' administrative floor above the sales floors. A passing secretary failed to spot us as we continued aloft. A slight jolt and sideways movement accompanied the cessation of ascent and the commencement of descent. I don't know whether we were relieved or disappointed. Fairfax House was never a great success and was finally demolished in 1988 to make way for the Galleries shopping mall. It was rumoured that the skeletons were discovered of customers who had strayed too far from sight of an exit. Everything else in the photograph was replaced by the Cabot Circus development.

In July 1984, Bristol's Nos 87 and 88 bus services became the last in the country to use the Bristol Lodekka, an innovative design of the Bristol company dating from a prototype of 1949 and continuously developed until production ceased in 1968. The photograph was taken on Wednesday 16 May 1979.

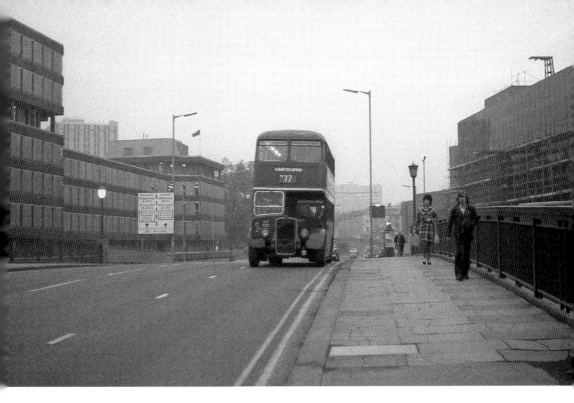

During the 1970s, Bristol became the biggest centre of the insurance industry outside London. Its offices, like mushrooms, seemed to spring up overnight. On the left, as an early dusk closes in on the afternoon of Wednesday 12 November 1975, we discern the aggregate panels and orange windows of the Clerical Medical building. It saw out the standard thirty-year lifespan of any throwaway modern building. On the right, still under construction and eventually occupied, I think, by IBM, this building has also disappeared in recent years. The bridge across the Floating Harbour has since been widened. All of these surroundings are modern, or at least recent, yet have completely vanished in the years since – even Tollgate House, dimly seen in the distance, and half of the Evening Post building alongside the Old Market roundabout.

The Bristol KSW-type bus, however, was built to last. Representing the final form of a design dating back to 1936, the utter ruggedness and reliability of these vehicles saw the company through a difficult period when 1970s industrial troubles led to a shortage of spares and late delivery of new vehicles. Many saw out an extended old age, largely on the gruelling services up and down Gloucester Road.

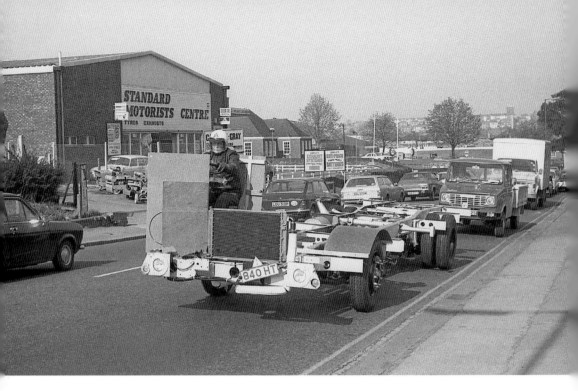

Above: Dissatisfied with its early Fiat and Thorneycroft motor buses, the Bristol Tramways & Carriage Co. started to build its own vehicles in 1908, soon making them available on the open market. In 1955, the operating and manufacturing companies were separated, the former becoming Bristol Omnibus Co. and the latter Bristol Commercial Vehicles. BCV built its chassis on two sites at Brislington, and they were often to be seen along the Bath Road on test drives or delivery runs to body makers, usually Eastern Coachworks of Lowestoft. Protection against the weather for the driver amounted to a couple of sheets of plywood. As part of a nationalised group under the control of the British Transport Commission, shares in BCV were acquired by British Leyland, which began a tiptoe process of killing off the Bristol company to leave the market clear for its own products. By the date of this photograph, Monday 17 April 1978, BCV was no longer allowed to make its highly regarded RE chassis for the home market. This example was probably destined for Ulsterbus, a public transport operator in Northern Ireland. BCV finally closed in 1983.

Opposite below: Cambridge Street, Totterdown, was just outside the destruction zone of the council's Three Lamps road scheme and escaped the great clearances going on a few hundred yards away when the photograph was taken on Wednesday 7 March 1973. As satellites of the shops that were being demolished in Wells Road, this little rank had little hope of survival. What chance had they, in any case, against out-of-town malls and giant supermarkets with lavishly provided free car parking? All these shops must once have been ordinary houses, converted by little more than an enlargement of the windows. Looking in through the doorway of the first establishment, we can see that the customer entered the 'passage' of the house and then turned right into what had been the 'front room'. Possibly, the old living room at the rear served as a store room and the proprietor and his wife lived above the shop. In the mind's eye one sees Leo dried peas, Camp coffee, Lyons swiss rolls, Witts's Wonderloaf and, moving with the times, Birds Eye fish fingers, kept in a 'deep freeze' among the Neilson's choc ices and Mivvis.

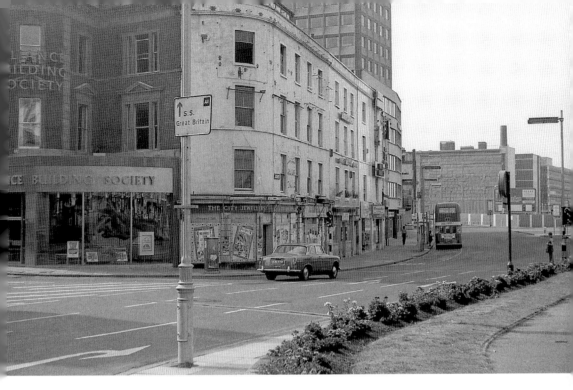

Above: Sunday morning on the Centre, 3 August 1975. The CWS building is finally down, though the Garrick's Head pub remains for the time being. The first few properties from the Baldwin Street corner are boarded up and await demolition. Since the 1960s, the council had been itching to widen the road here, which explains why the Bristol & West Building Society's offices (now the Radisson Blu Hotel) are set further back from the pavement. Had the condemned properties been demolished, there would have been nothing but modern buildings the whole length of Broad Quay. They survive to the present day, further beneficiaries of the mid-1970s conservation backlash.

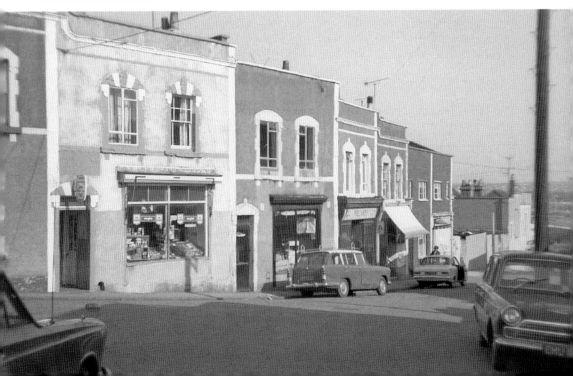

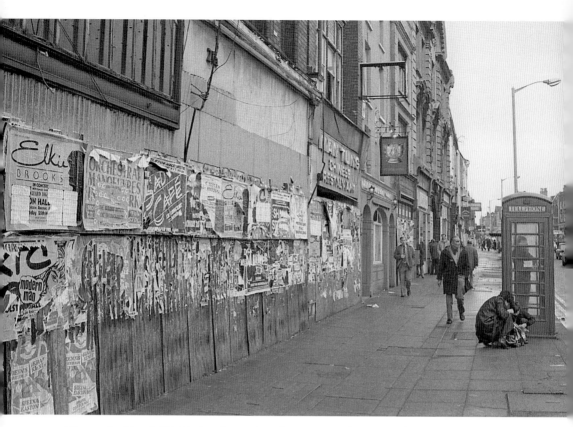

The north side of Old Market Street, Monday 22 December 1980. The King's Cinema, off left, was soon to go, but the other condemned properties were reprieved. A checklist of contemporary singing talent among the fly-posters on the left: prominent in the foreground is XTC, a singing beat combo from Swindon; the Colston Hall has a triple-bill consisting of Denis Waterman, Gerard Kenny and Sheena Easton; also visible are the names of Elkie Brooks, Sad Café, Orchestral Manoeuvres in the Dark, Steeleye Span, Chris de Burgh and Cardiff's own Shakin' Stevens.

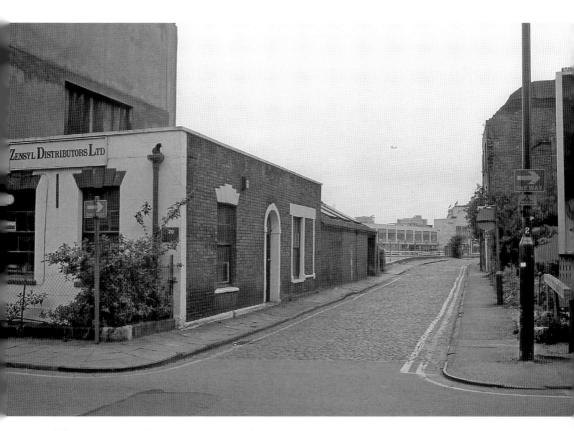

Norfolk Street, St Paul's, no longer exists, though its ghost lives on as a gated entrance to the Spectrum building. The setts (popularly 'cobbles') are still there, but the cast-iron kerbing – a Bristol peculiarity – and picturesquely uneven flagstones have gone. A couple of hundred yards away, we see the backs of the Broadmead shops, but the physical and psychological barrier of the Inner Circuit Road passes across the middle distance, and all here is dereliction. The 'Georgian' terraces that now stand left and right of this view were strangely absent when the photograph was taken on Easter Monday 20 April 1981.

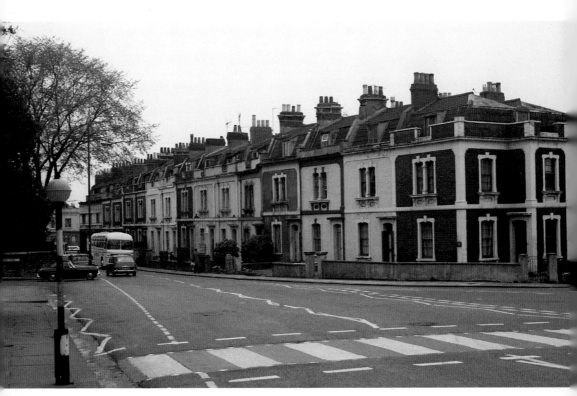

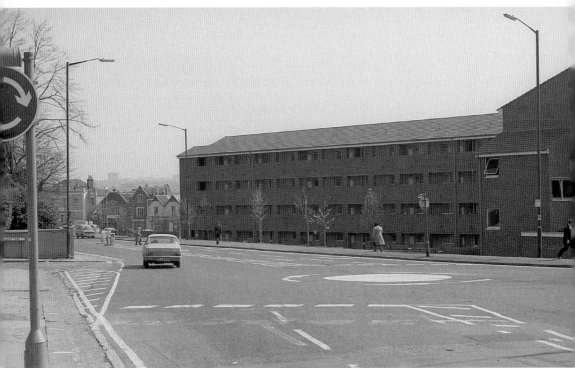

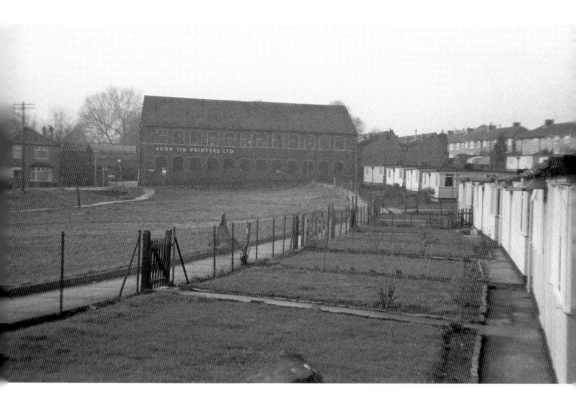

Above: Wartime prefabs – 'prefrabs' as it was sometimes pronounced – in the 'dip' at the bottom of Plummer's Hill, St George, seen on Tuesday 16 January 1973. As an interim measure intended to last five years, they enjoyed remarkable longevity and were well liked by their tenants. In places, they have been replaced in near facsimile. The last of those in the photograph was removed in 2007 and conventional houses built on the site. It is believed that more prefabs had once stood on the empty strip of ground in front of the factory, but were flooded during the 1950s. The plot remains empty. The stream that flows past here must be the one that supplies the lake in St George's Park, which has been known to overflow and cause serious flooding in Redfield. The factory buildings were once part of the local workhouse and have since been converted to flats. Avon Tin Printers had another factory in Station Road, New Cheltenham.

Opposite above: Looking along Ashley Road, St Paul's, from its junction with City Road, Saturday 20 April 1974. In those days, one had only to keep one's eyes peeled for boarded-up windows to know what was coming down next. The three properties closest to the camera were still occupied, but the remainder were empty and, in some cases, had been for years. Squatters moved in and proved difficult to evict. The houses, solid and serviceable as far as one could see, were demolished later in the year. Had they survived, the onward march of central heating would have cost them their beautiful chimney pots.

Opposite below: The same view on Thursday 9 April 1981. The mini-roundabout came in 1977, and the far kerb was set back in 1980. Perhaps road widening had been the pretext for demolishing the earlier houses. Replacing those substantial family homes (refurbished, what would they now be worth?) came this filing cabinet for people, consisting of mere cells or 'dwelling units' such as only the twentieth century could have produced. It might have been worse; at least the era of high-rise was over. These flats had a short life and have since been demolished and replaced.

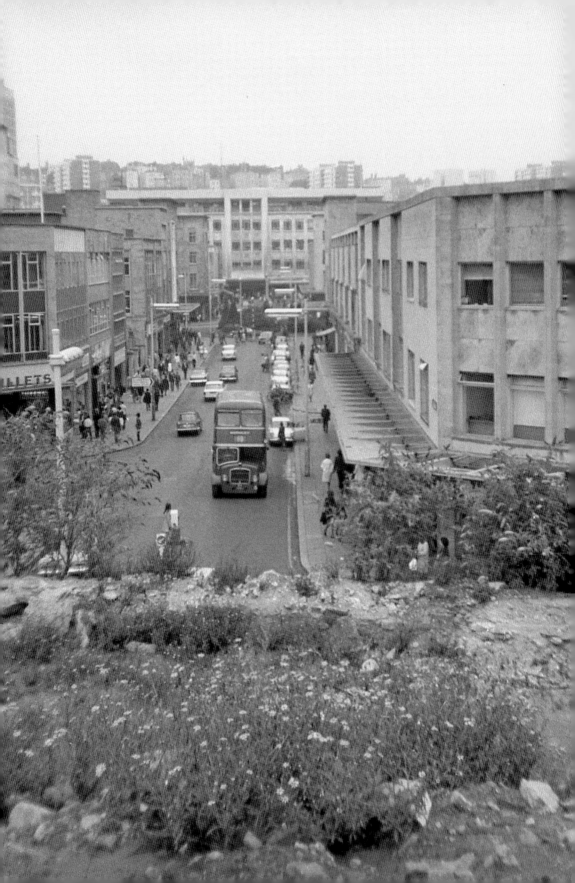

Right: Another look at the pre-pedestrian Broadmead, taken from Nelson Street during 1973. It is summer, for the bus driver crossing Silver Street wears the Tilling Group summer tunic, known in bus company lingo as an 'ice-cream coat'. The Swears & Wells store on the Union Street corner was the first of the new Broadmead shops to open for business. Just beyond, the prominent white-fronted building was Woolworths, demolished for the entrance to the Galleries shopping mall. Behind the H. Samuel clock, and causing an interruption of the roofline, is a solitary pre-war survival, often overlooked. The *Evening Post* still occupies its Silver Street premises. At Saturday teatime, little knots of chain-smoking men in raincoats assembled on the pavements outside suburban newsagents' shops awaiting delivery of *Green 'Un*, a special edition, printed on green paper, containing all the afternoon's football and sporting results. There was a kindred publication, the *Pink 'Un*, though I never understood the distinction between the two. In the mid-1970s, the *Post* moved to Temple Way.

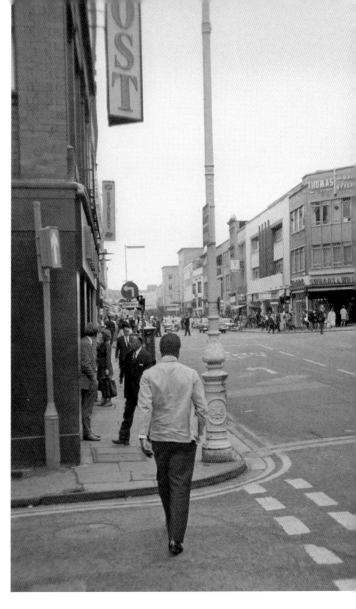

Opposite: That Bristol's beautiful pre-war shopping district – I know it only from photographs – was lost in the war couldn't be helped. Why not rebuild on the devastated site? Instead, in a further disaster for the city, the main shopping centre was transplanted a few hundred yards to the north, and this 1950s dog's dinner arose in place of old streets that had come through the bombing largely undamaged. Here, looking down into Merchant Street during the summer of 1973, overgrown wartime rubble is still evident in the foreground. The Broadmead shopping centre was pedestrianised later in the year. The old Castle Street shopping area slumbered on as an impromptu car park for decades while the city council procrastinated about what to do with it. A proposal for a new museum was cancelled at an advanced stage of planning. In the end, they bulldozed the rubble into tastefully landscaped contours, put down some topsoil, grassed it over, planted some saplings and created Castle Park. A park is a pleasant enough thing, of course, but now there seems to be a void where the city's heart should be. Most of the left side of Merchant Street went in the 1990s for the Galleries mall; the right side disappeared in the clearances for the Cabot Circus development.

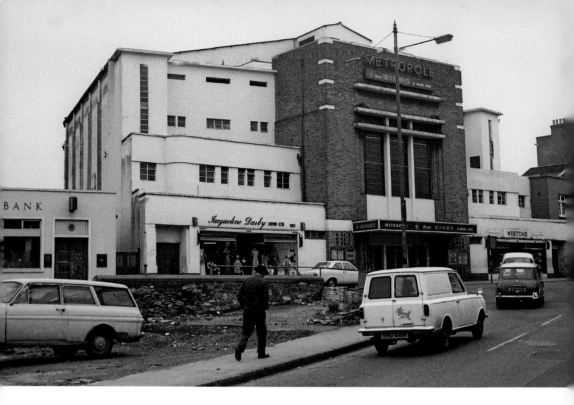

'Are you sixteen?'

Once again, the dreaded question, addressed to me from behind the desk of a box office by a basilisk-eyed, middle-aged woman wearing a brown tunic with epaulettes and pleated skirt hanging from childbirth-widened hips.

'Yeeaa...' I lied, a little open-mouthed and in a slightly affronted tone intended to convey wounded integrity.

By asking, she had fulfilled her obligations and, if I had lied, how was she to know? Mine was another two bob to add to the receipts of this hopelessly declining business. It was the same every week: last Saturday, it might have been the Scala, Zetland Road, the Ritz, Brislington, the Gaiety, Knowle, the Vandyck, Fishponds or even, if a particularly tempting programme justified expenditure on bus fare, the Charlton, in far-off Keynsham. This week, it was the Metropole, Ashley Road, St Paul's.

There was a moment's hesitation, designed to make me sweat, but the gnarled, age-spotted hand, with its wedding ring grown too tight for arthritic fingers, eventually depressed an invisible apparatus and a salmon-pink ticket was extruded from beneath a little flap just in front of the impressed word 'Automaticket'. 'Shame the devil,' said the uniformed usher as he tore my ticket and thrust half back into my palm, 'I wish I'd looked that young when I was sixteen.' Of course, no sixteen year old wants to look younger, but we'll let that pass.

The film I'd come to see was *Tamahine*, an innocuous romantic comedy featuring the forgotten Hong Kong-born starlet, Nancy Kwan. There were one or two kissing scenes, and at one point Miss Kwan's bottom was briefly visible. This had qualified the film for an 'A' certificate, meaning that no one under the age of sixteen could see it unless accompanied by an adult, ready to provide counsel at moments of moral ambivalence. The Metropole opened in 1913, but the structure we see here was a 1938 rebuild. By the time of the photograph, Saturday 20 April 1974, it had been a bingo club for six years. In March 1980, it became a furniture store and was finally demolished in September 1989.

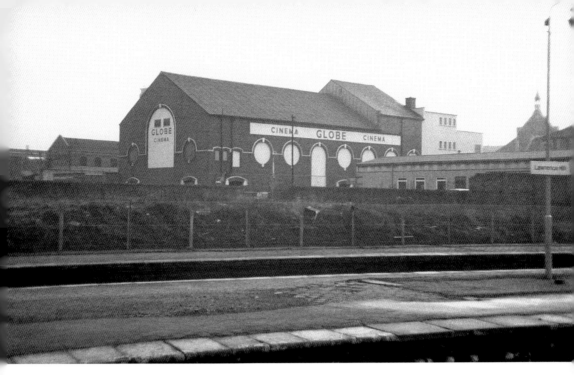

Another suburban cinema, the Globe, seen on Tuesday 16 January 1973 from one of the platforms of Lawrence Hill station. The establishment had closed on 7 January and the building was demolished during July and August. From a pre-war total of over fifty, Bristol's cinemas had declined in number to fewer than twenty. For ten years, starting in around 1963, I was a weekly attendee. With a school classmate, I spent many a windswept twenty minutes after 'Doors Open', propositioning adults to escort us into A-certificate films. There were many ill-natured refusals. This became tiresome, and once we'd turned thirteen or so, we began trying to bluff our own way in. Finding ourselves consistently successful, we tried our luck at an X-rated programme. We pulled it off at the first attempt, seeing Psycho at His Majesty's, Eastville. Our luck held, and we got in for *The Victors* at the Rex, Bedminster, and *Boccaccio '70* at the Metropole. This latter was the choice of my friend, a Greek Cypriot boy (his father managed the 49 Steps restaurant at the foot of Christmas Steps) who fancied himself a cosmopolitan sophisticate. Ignominy awaited when – getting cocky now – we tried to see *The L-Shaped Room* at the Orpheus, Henleaze. Born in July, I was always among the youngest in my class and my friend was nearly a year older. Furthermore, I had just had a haircut, which always made me look younger. 'You may be sixteen,' said the woman in the box office to my friend, before turning, with a scowl, to me, 'but you're not.' I slunk out, terrible-eyed, my friend following. It was a grievous humiliation, but the matter was redressed when he joined the Bristol Film Club, enrolling over the phone from a public call box. When he turned up for a showing at the club's premises in King Square, he was told that membership was restricted to over-sixteens. Over the phone, his as yet unbroken voice had been mistaken for that of a woman.

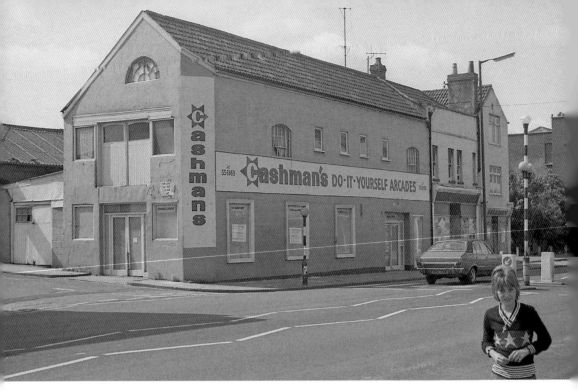

Above: Cashman's DIY emporium in Stapleton Road, photographed on Sunday 1 June 1975. Businesses like this would lose their custom to B&Q and Wickes in the years ahead and, from the blanked-out windows, it looks as though Cashman's has already fallen by the wayside. The building was obviously of some antiquity. It is believed to have been a malthouse, dating from the first decades of the nineteenth century. It was owned by Thomas Hulbert, whose name lives on in nearby Hulbert Street. The building was demolished in June 1977. Would the youthful onlooker have been a devotee of the Bay City Rollers singing group?

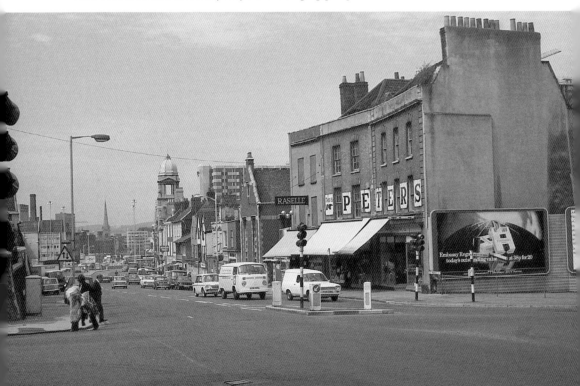

Above: No place in Bristol has changed so often or as completely as Newfoundland Street. It now seems incredible that, for some years after it opened, all the M32's traffic was funnelled into this minor street with its narrow pavements. At one time, Newfoundland Street had continued, as Milk Street, directly into the Horsefair. The Inner Circuit Road severed the connection. The photograph was taken on Wednesday 19 January 1972. Piecemeal demolition of the left side, followed by serial widenings had, by the early 1980s, brought a dual-carriageway connection as far as Bond Street. Older readers will remember the elaborate system of traffic lights facing the Littlewoods store. This is at about the point where, today, the motorway's traffic bifurcates to pass on either side of the Cabot Circus development. Five lanes of traffic hurtles past in one direction to join the motorway system while, on the far side of a grass island, another five lanes enter the city. Newfoundland Street no longer exists, and these few hundred yards of tyre-scorched asphalt have become part of Bond Street. For those trying to get their bearings, the modern brick wall on the right survives today as part of a garage and MOT centre and has seen it all come and go.

Opposite below: A general view of Old Market Street, Monday 23 June 1975. The first two businesses, Peters and Raselle, occupied three Georgian houses; a fourth, where the advertisement hoardings are, had been demolished to ease the path of traffic turning into Lawford Street. Raselle's (popularly 'Razzle's') had been trading from these premises for 188 years when finally they moved to another shop not far away in Stapleton Road where, I am happy to report, they continue to thrive. Indeed, pawnbrokers have made a modest comeback in recent years. Peters, who sold outdoor and camping equipment, must have closed at the same time, and the lively enamelled letters over the shopfront were lost. Pull-down canvas shop blinds of the type seen here are now rare. The appearance of these two shops had remained unchanged since before the war. The buildings have now been restored to within an inch of their lives and encased in a new development, which closes vice-like around them, partially reinstating the corner property. Note the Weddel van, halfway down on the left. The wholesale meat trade had been established for many years on the south side of Old Market Street and West Street. The premises were open to the street, and food-hygiene concerns led to their closure.

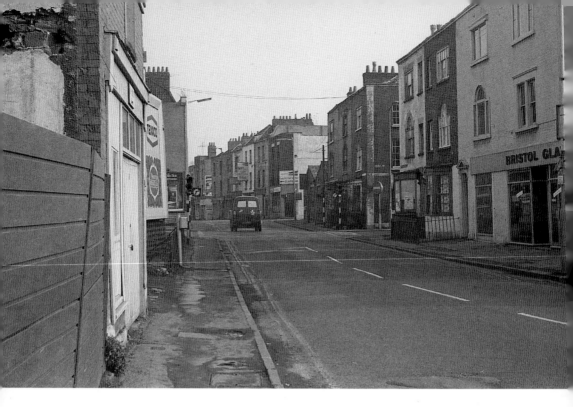

Above: The opposite view of Newfoundland Street, taken on Tuesday 1 January 1974, the first New Year's Day that was a bank holiday. Here, I was standing close to the junction with Bond Street, with my back to the Littlewoods store. The right-hand side beyond the Stratton Street traffic lights was demolished the following month. The closer rank lingered on, obstructing further widening. Eventually, there were moves to have the buildings listed. The council, getting wind of this, sent the bulldozers in early on a Sunday morning, 20 October 1985. At the time, as a driver working from the bus station, I passed the houses, intact, on a journey out to Yate; by the time I got back, two hours later, there was nothing but a pile of eighteenth-century bricks and timbers. The camera position would now be somewhere on the ground floor of the House of Fraser department store.

Opposite above: Fortunately, the greater part of Totterdown was outside the area cleared for the Three Lamps road scheme and – let us give thanks – survives to the present day. With its long streets of terraced houses and its hilltop position overlooking the Avon, Totterdown is a kind of working-class counterpart of Clifton. On Sunday 3 February 1974, there are two replacement roofs so far, but not a single uPVC window frame. A few 405-line television aerials survive, but satellite dishes were many years in the future.

Opposite below: A photograph taken with a 135-mm lens, which foreshortens the perspective and exaggerates the steepness of the slope. Nevertheless, some of the steepest streets in Britain are up here: Vale Street, just around the corner, is said to be the steepest. The rival claim of a certain lesser English city is not countenanced by Bristolians.

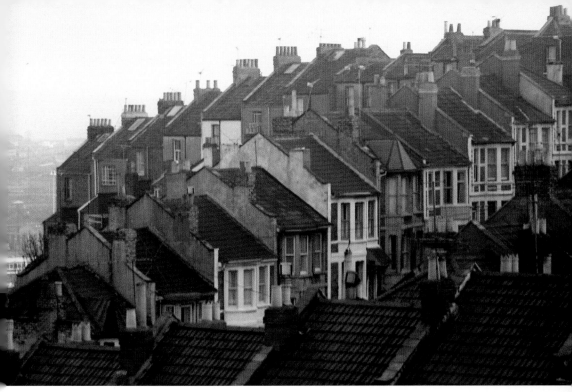

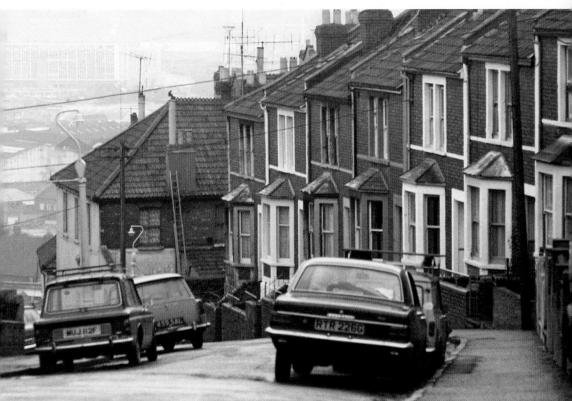

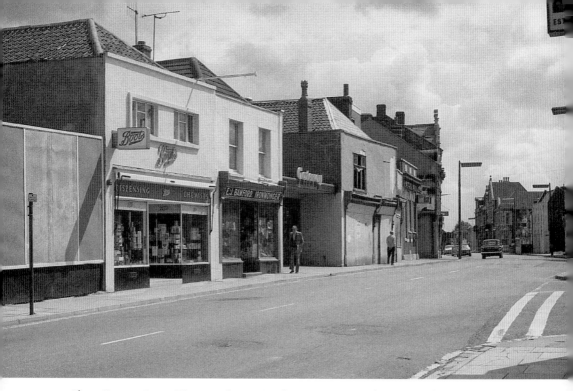

Above: Regent Street, Kingswood, on a Sunday morning, 14 July 1974. By this time, almost every suburban high street in the country had been de-vitalised by a pedestrianised 'shopping precinct'. The Kings Chase Shopping Centre, taking shape behind the hoarding on the left, has been the cross that Kingswood had to bear. The first two shops are a branch of Boots and E. J. Bamford, ironmonger. Their site is now 'Chaser's' discotheque. Beyond is a small Gateway supermarket. Gateway was, I think, the lineal descendant of Maypole, via Lipton's. It later morphed into Somerfield. What remains of this rank has been rebuilt or mutilated beyond recognition. Shopping precincts were beginning to go out of favour, and not many more were built.

Opposite above: The periphery of the area cleared in the demolition of Newtown. For some reason, two houses remain standing in Trinity Street. The camera position was at the end of Waterloo Road, with the surface of Albany Place in the foreground. The latter has entirely disappeared, and Waterloo Road now continues to meet a realigned Trinity Street. These large expanses of cleared ground tended to attract travellers' encampments and unauthorised car breaking. The open space in the right distance has since been landscaped, planted, threaded through with paths and provided with 'play areas'. National Carriers Ltd was a renamed British Railways' parcels service. The car was a Ford Consul.

Opposite below: This was, I think, the last surviving fragment of central Bristol's once-extensive bomb sites. It had suffered the fate of many and been made into a car park. Unlike most, it had been surfaced and probably belonged to the Courage Brewery. The rudimentary fencing, rooted in little dollops of concrete, is characteristic. Photographed on Thursday 9 April 1981, the plot had been empty for almost exactly forty years. Bland flats arose during the 1990s – the site probably made available by Courage's departure. The tooled pennant flagstones, admittedly rather untidily patched, were lost. For a while, a few bomb sites survived a mile or two distant on the slopes above Hotwell Road, but they too have vanished.

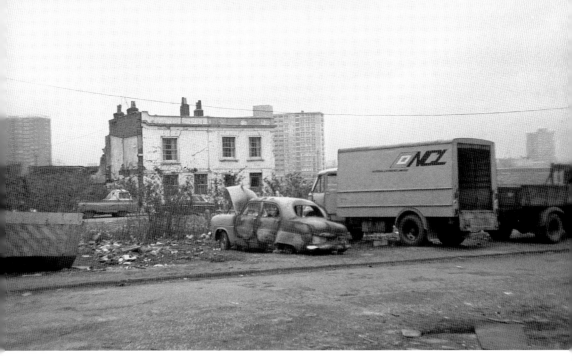

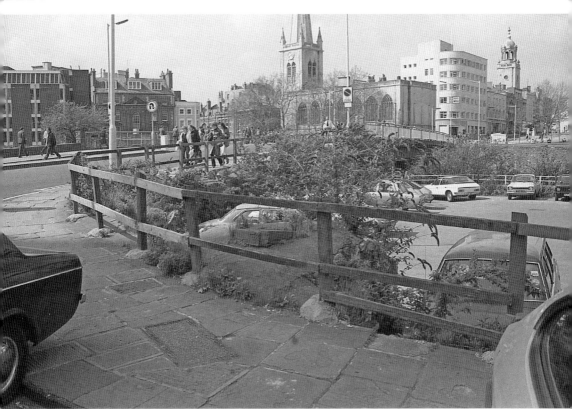

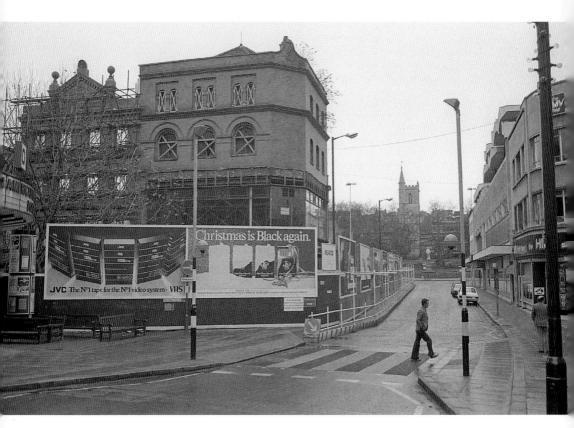

By the early 1980s, it had become almost impossible to pull down any pre-twentieth-century structure. The trouble was that old buildings were often unsuited to modern uses. In came 'façading'. Here, behind the advertisement hoardings, on Sunday 5 December 1982, the frontage of the former Phillip's furniture store is being kept upright while new shops are inserted behind. The advertisements are themselves period pieces: there is a diabolical cigarette poster and another for Video Home System (VHS) videotapes – big sellers at Christmas. By now, VHS had almost seen off competition from the technically superior Betamax system. *An American Werewolf in London* is showing at the Odeon. HMV were in possession of the old Strode Cosh & Penfold chemist's shop on the Broadmead corner; they were to move to larger premises, giving way to the familiar Tesco Metro. At the far end of Lower Union Street, the statue of Samuel Morley, a nineteenth-century philanthropist and Bristol MP, stands on the traffic island in the Horsefair. It had first been sited in the road outside St Nicholas's Church in Baldwin Street, but had become an impediment to traffic. Another relocation was to come, for statues of stodgy Victorian grandees have no place in the whizzy new Bristol; Morley gave way to the bizarre, trampoline-like 'Broadmead Gateway'.

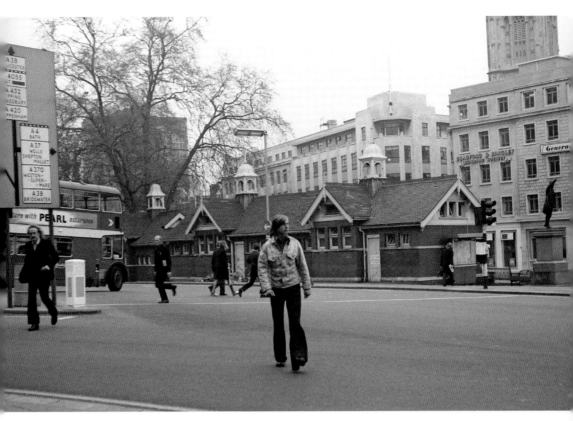

On Wednesday 17 April 1974, the doors of the city centre's red-brick public lavatories, with their charming belfries, are firmly shut. The building was demolished in December, replaced by new amenities in the basement of the Colston Centre. The 'You Are Here' city map at the end of the building was a trysting place for a whole generation of young Bristolians. In 1966, the Aust Ferry had been replaced by the first Severn Bridge; note that the word 'Ferry' has been blacked out on the road sign. Flared trousers and denim jackets were among the sartorial constants of the age. No sign yet of trainers or stubbled craniums.

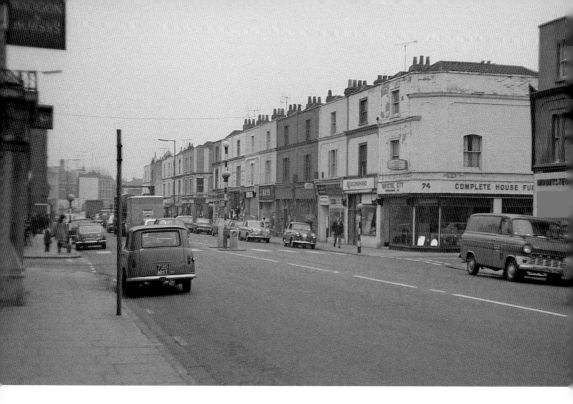

A view towards the city, taken on Thursday 24 February 1972, when Stapleton Road was a far busier and more important thoroughfare than now. The shops extended behind the camera all the way to Eastville Junction, but in 1975, most of the traffic was drawn off by the M32. At the same time, the new Easton Way dual carriageway cut Stapleton Road into two and prevented the passage of traffic from one half to the other. Demolition of the closely packed houses in Easton robbed the shops of most of their catchment area. Although the residents were rehoused locally in tower blocks, the paths and dead acres of grass between them were strangely deserted. As a lively mixed shopping centre, serving a traditional working-class clientèle, Stapleton Road's days were numbered.

The first parked car, 735 MHT, is, I think, a Hillman Minx Estate. Notice that there are no 'hatched markings' on either side of the pedestrian crossing, and cars park right up to the 'zebra' stripes. Many of these shops were customers of my first employers and are forever associated in my mind with an embarrassing incident that occurred when I was about seventeen. The terrible details may be quickly told. I was sitting in our van somewhere along this length of kerb waiting for my driver, Nobby, to return from one of his calls. I decided to cross the road to buy a newspaper. A headscarfed woman in her sixties entered the shop ahead of me, and I attempted to slip in behind her while the door was still ajar. Unfortunately, she, neglecting to look behind, fumbled for the door handle, but instead placed her hand squarely on the authorial wedding tackle. Puzzled, I suppose, by the unhandle-like form in her grasp, she retained her hold and fumbled in rummaging, investigative movements for some seconds – it seemed an eternity – before turning to discover her error. Poor old woman. I can still see the look of horror on her face.

'Oh sorry!' she said, in a kind of gasp.

'S'alright', I muttered, gruffly.

I made my purchase and left.

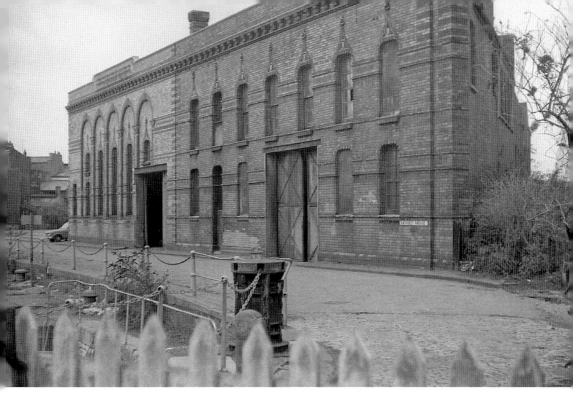

Bathurst Parade, seen on Saturday 25 October 1975. This building, a notable example of the 'Bristol Byzantine' style, was another of William Bruce Gingell's essays in yellow bricks with red trimmings. It was put up in 1874 for the Robinson Oil Seed Co. It is really two buildings: the left half was the warehouse and the right its office. The windows of the two parts are different but clearly related, and Gingell further unified his composition with a strong cornice. It was unfortunate that so carefully considered a design should have been disfigured by two later entrances crudely inserted beneath lengths of steel joist. In the early 1980s, all this quayside was sanitised as part of the 'Merchants Landing' development. I'm afraid I can't bring myself to write this toe-curling name unless between dissociative inverted commas. The building was demolished, but its façade was cleaned and left standing as a frontage for flats and squash courts. The two entrances were removed and correct brickwork reinstated.

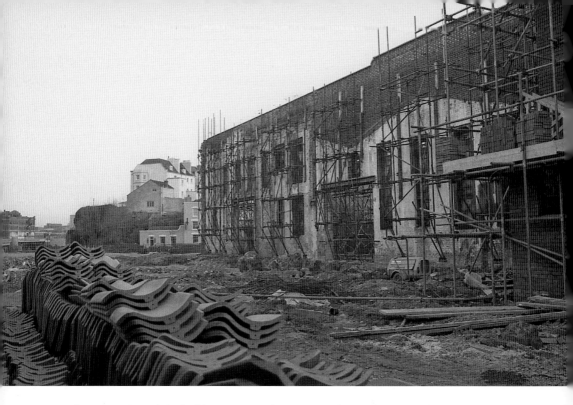

Above: Façading of the buildings seen in the previous photograph. From the imprint on the back of the brickwork, it appears that the jazzy frontage must always have been a fancy screen hiding a functional, shed-like structure. The photograph was taken on Saturday 19 December 1981, a horribly cold day at the beginning of one of the nastiest winters for many years. Today, it is unlikely that stacks of valuable, brand-new pantiles would be left unguarded in the open over the Christmas and New Year holiday period. The Ostrich Inn peeps out from behind the propped-up brickwork.

Opposite above: Trinity Street, just around the corner from West Street, looking towards the two gas holders in Day's Road, Sunday 3 February 1974. The gasworks had been established by the Bristol Gas Co. during the 1860s and were a landmark visible from many parts of the city. On the left, new housing has arisen over some of the vanished streets of Newtown. ALW 479B is a Ford Zephyr; further along are a Mk I Ford Cortina and a Bedford TK lorry, its load roped beneath tarpaulin sheets. The gasworks were dismantled in 1981.

Opposite below: The Western Counties Agricultural Association's warehouse in Redcliff Backs, photographed on Monday 20 April 1981. The opposite side fronts the Floating Harbour. This being Easter Monday, the road is, for once, clear of parked cars. Erected in 1909, the building was the work of the Leeds architect W. A. Brown. Though faced with bricks, it represents an early use, in Bristol, of a reinforced concrete frame. The oriel-like structures, jutting out, had once housed hoists. The landing platforms – one up, one down – can be seen underneath. Derelict for many years, the building was the subject of a design competition in 1983. In 1995, work finally started. It was gutted for an internal light well and converted to flats.

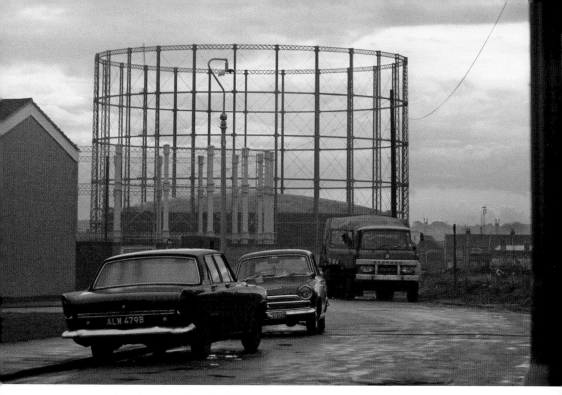

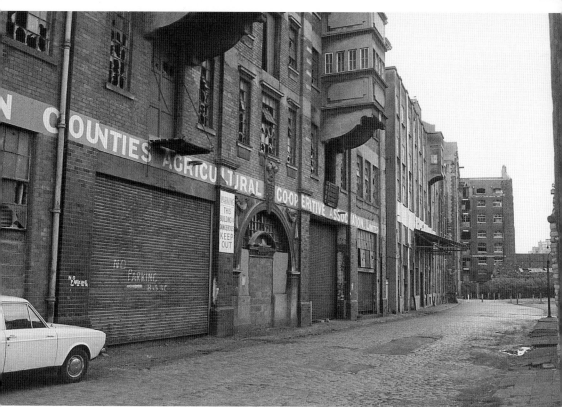

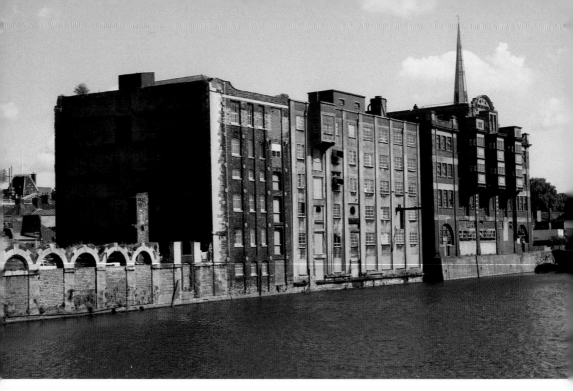

Above: The opposite view of the same buildings, seen on Wednesday 23 July 1975. The little row of arches above the waterline preserves the memory of a building lost to incendiary bombs during the war. New flats now fill the site. At the time of writing, the building in the centre of this view remains derelict. Cantilevered oriels housing hoists match those on the landward side.

Opposite above: An unfamiliar view of St Gabriel's, Easton, briefly exposed by demolition of the adjoining Church of England school, whose rubble can be seen in the foreground. The council was eager to demolish the church, a distinguished building of 1870 by J. C. Neale, and replace it with more of the sort of thing we see in the background. Eventually, they trumped up the excuse of subsidence from neighbouring Easton Colliery. The photograph was taken on Sunday 1 June 1975, and the church came down in September. Neale was killed by a train in Exeter; few of his buildings survive.

Opposite below: Pritchard Street, St Paul's, looking into Stratton Street, with Newfoundland Street crossing just behind the Ford Anglia, Monday 20 April 1981. Stratton Street led into Lawford Street, forming a handy shortcut between East Bristol and the northerly parts, cutting out Old Market, Bond Street and Stokes Croft. The area had been left to deteriorate for years, but by the time it was 'ripe for redevelopment', redevelopment had become unpopular and difficult to get away with. The buildings were obviously beyond saving. On the right came a brand-new office building with stick-on Georgian trimmings; on the left, a spurious Georgian terrace constructed from machine-made bricks bonded with Portland cement, complete with mastic-filled expansion joints. Cabot Circus came in the middle distance, completely obliterating Stratton Street.

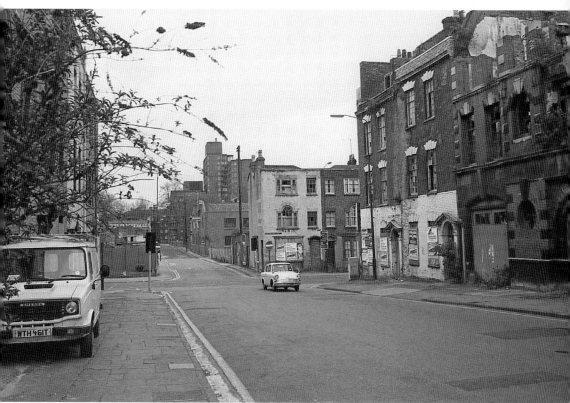

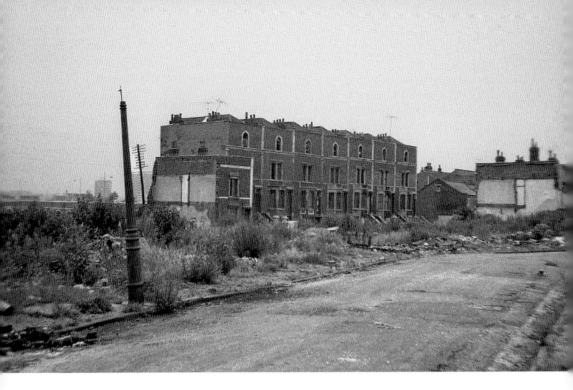

Above: A terrace of substantial, four-storey houses with half basements in Digby Street, Barton Hill, photographed on Friday 26 June 1970. One property, in the centre of the rank, was still occupied (by a blind man), and it is possible that the others had been left to hold it up. In the left foreground, a lamp post is still rooted in the pavement of Bridge Street, whose surface and kerbs remain, though the houses have gone.

Opposite above: In County Street, Totterdown, one man, Henry Bradbeer, had refused to move out during the clearances of 1973. On Thursday 16 April 1981, he was still sitting tight, with his Rover at the kerb and another house left standing on either side. By this time, the road interchange, for which all the other houses had been demolished, was long forgotten. This trio finally came down early in 1986. Older readers may remember that the scene was painted by the American artist Nancy Kominsky in her Sunday morning television series *Paint Along with Nancy*.

Opposite below: A one-way torrent of traffic during the week, West Street, Old Market, is eerily quiet in this Sunday morning shot, taken on 3 February 1974. Rather moth-eaten and down-at-heel in 1974, this is now part of a conservation area. Most of what we see survives, but there has been some discreet infilling and an outbreak of 'sympathetic' shopfronts. The Black Horse public house, in its latter years a great hang-out of the city's Irish community, has gone; so has the wholesale meat trade. The Gilbert Scott telephone kiosk has been removed, but the ventilator, for an electricity substation, endures. The road surface, as elsewhere, is now hideously disfigured by lane markings, varicoloured asphalt, bus bays and yellow lines.

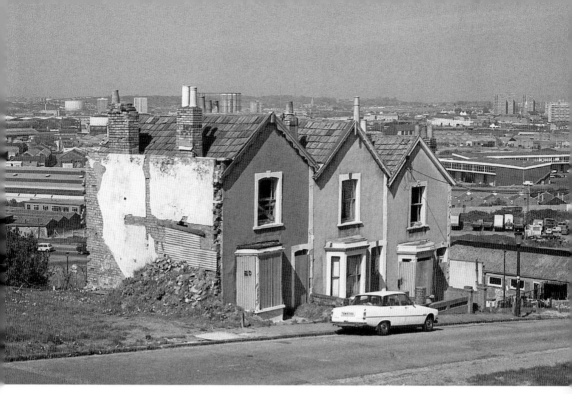

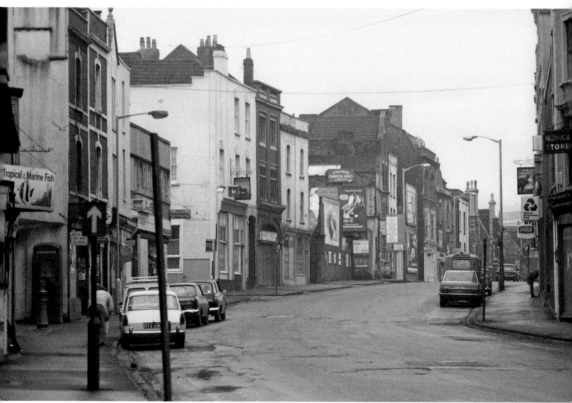

Left: Wellington Road, seen from close to the junction with Wade Street, Saturday 28 February 1970. The buildings were intact, but gradual demolition, associated with the construction of Newfoundland Way, led to a loss of all the houses and workshops during the first half of the new decade. The gaslights were some of the last genuine, unselfconscious examples in the city. Where gaslights exist today, they are either artificially retained for 'heritage' reasons (often converted to electricity) or modern reproductions, wrongly spaced and about twice the height of any genuine gaslight, presumably to comply with Euro-directives or simply to reduce vulnerability to vandalism. The numberplate of the Somerset-registered Ford Anglia would now be quite valuable.

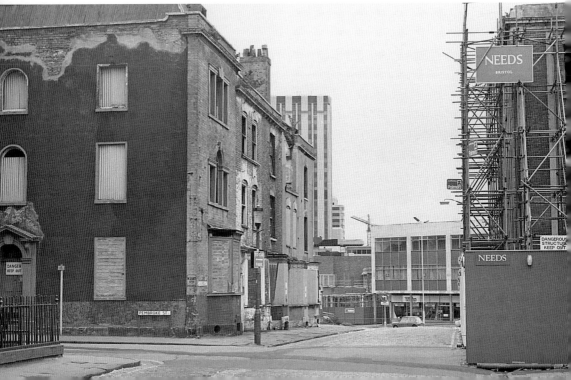

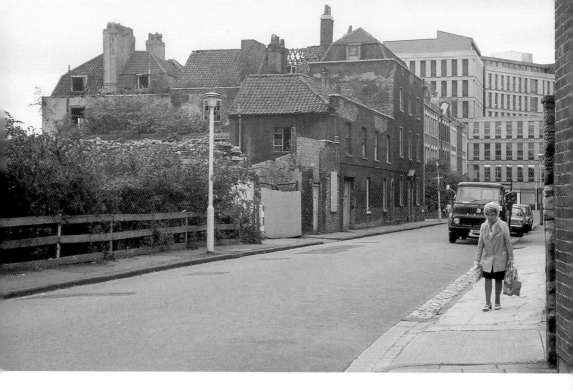

Opposite below: Looking from the south-east corner of Brunswick Square along Gloucester Street to Bond Street and the Broadmead shops, Monday 20 April 1981. Off right the south side of the square, of 1766–71 and attributed to Thomas Paty, is being façaded ready for a new biscuit-coloured office block, Bond Street House, to be inserted behind. The houses in Gloucester Street survive as flats, in semi-authentic condition and cleaned to a raw newness. Windows have been renewed in smoothly planed, sharp-cornered timber, using flat panes of machine-made plate glass. The 'Bristol black' render has been lost from the Pembroke Street frontage.

Above: The backs of the same houses seen from Pembroke Street on Monday 29 September 1975. The blue glass edifice of the Spectrum building now stands on the left. Avon House North rises in the distance beyond Paty's seemly terrace in Brunswick Square. Developers were fond of arguing that modern buildings placed among older ones presented the observer with an interesting juxtaposition of styles. This may have been true, but the comparison was seldom to the advantage of the newer structure.

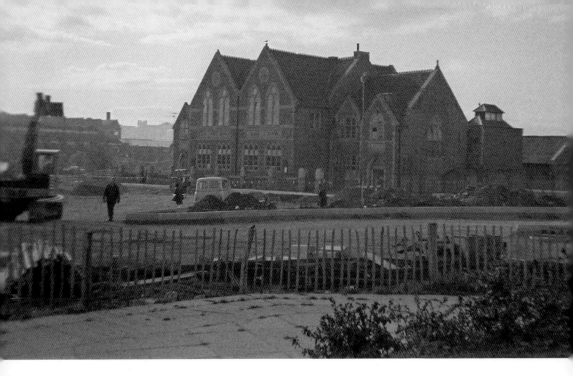

Above: Easton Road Board School, a work of 1887 by Charles Hansom and Frederick Bligh Bond, photographed on Friday 3 March 1973. The huge new Lawrence Hill roundabout is being laid out on the left, and Easton Way joins from the right. Easton Way was to have formed part of the Outer Circuit Road. A mile or two away, Totterdown was being razed in readiness for the next section, which was never built. For twenty years, Easton Way served no purpose except to devitalise Stapleton Road by carrying off its traffic and merging it with that of Lawrence Hill, worsening the morning traffic. Later, it was linked to the Bath Road at Arno's Court, partly achieving, in modified form, its intended purpose.

Opposite below: 'If these old walls could speak, they'd tell some tales', my father muttered as he looked down from the top deck of the bus. We used the No. 18 bus service – Downend (Trident) to Clifton – for outings to the Downs, the Suspension Bridge and Leigh Woods, and its route took us along Newfoundland Road. Once, as the bus slowed to a stop, my mother's gaze came to rest on an upstairs window and she looked in to see a man taking off his vest. This had confirmed, in her opinion, that the area was 'common'. Our family's position on the socio-economic ladder was hardly exalted, but I could tell that we were a little better off than the people who lived here. In fact, 'Newfoundland Road' was a fixture in our family discourse, invoked whenever an image of unseemliness or raffishness was required. 'Don't lean out of the bedroom window,' my mother told me and my sister, 'it makes the place look like Newfoundland Road.' We all need someone to look down on. To me, this inner-city Victorian working-class district (Georgian in places, as you got to the far end and approached the centre of the city) seemed, and still seems, preferable to the ghastly tower blocks that replaced it. In those days, the late 1950s, 'commonwealth' immigrants first began to appear in large numbers. This population has largely moved on and been replenished from later waves of migration. The fronts of the houses on the left, which were older than most of the street, leaned backwards noticeably. They looked unsafe, but the inclination is visible in photographs taken during the 1920s. This view dates from January 1972. The left side had gone by 1975, demolished for Newfoundland Way. The right side is still mostly intact.

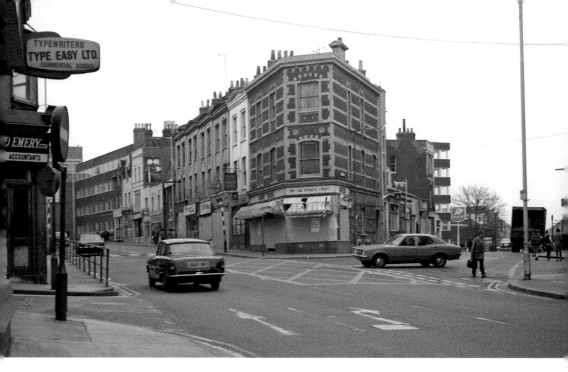

Above: When photographed on Saturday 20 April 1974, all the buildings on the triangular plot formed by the junction of City Road and Stokes Croft were condemned and boarded up. The mid-1970s conservation backlash came too late to save the corner building, but the rest survived and were refurbished. The corner plot is still empty today, apart from an advertisement hoarding and some bollards. As usual, there has been a grievous loss of chimneys and chimney pots. The pub beyond the junction appears to have had entrances in both City Road and Stokes Croft. The National Benzole filling station in City Road is now an empty plot used for parking a few cars. At this time, City Road was infamous as the headquarters of Bristol's 'red light' commerce, which was conducted with some blatancy.

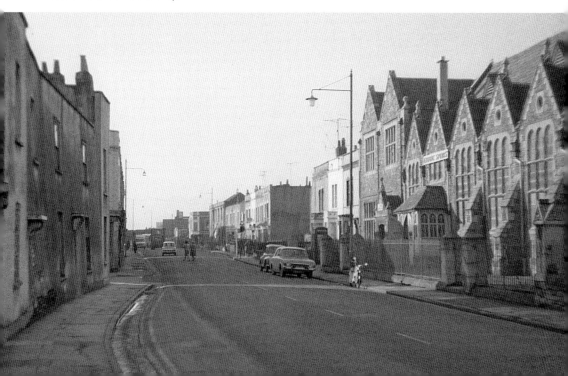

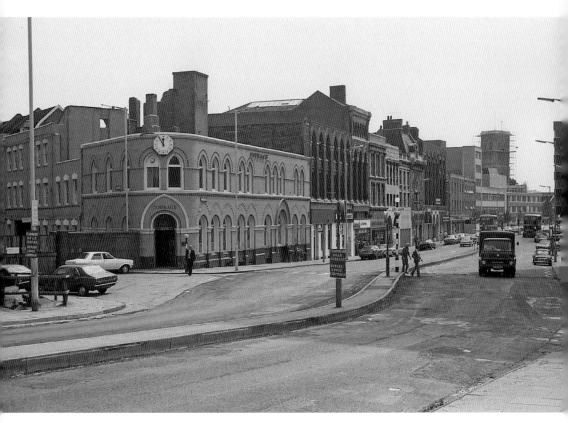

Victoria Street's wartime losses were made good during the 1950s and 1960s, according to the latest ideas in architecture and planning. An example may be seen in the middle distance, beneath the tower of Temple Church. An especially grievous loss, which I dimly remember, was Henry Crisp's carriage works down at the Temple Meads end, in its last years a branch of Henly's Garage. Today, this rank is all that remains of the street's nineteenth-century fabric. The building on the corner with the clock (its numerals had once spelled out GEORGES BEERS) had begun life as the Talbot Hotel. It had lost its top two storeys to incendiary bombs, which also appear to have accounted for the upper floor of the first house in Bath Street. Most of the buildings in the rank were acquired over the years by the Courage Brewery, probably with a view to demolition, and were let on short leases. With appalling effrontery, Courage demanded that it be allowed to incorporate Bath Street into its site and demolish some eighteenth-century houses on the north side, so that its lorries might more conveniently manoeuvre. It threatened to move out of Bristol if it were not allowed to do this. For the next quarter century, Bath Street, a public thoroughfare, was closed off behind tall gates, and its traffic was rerouted along Counterslip. In the end, Courage pulled out anyway. The Victorian polychrome brick of the hotel had become unfashionable and been hidden under grey masonry paint. In the 1990s, in a fine job of restoration, the brickwork was re-exposed and the top two storeys reinstated. This gain was countered by the loss of the property at the far end of the rank, on the Counterslip corner. The remaining buildings became façades in front of new offices, with attic storeys added. The photograph was taken on Monday 23 June 1975.

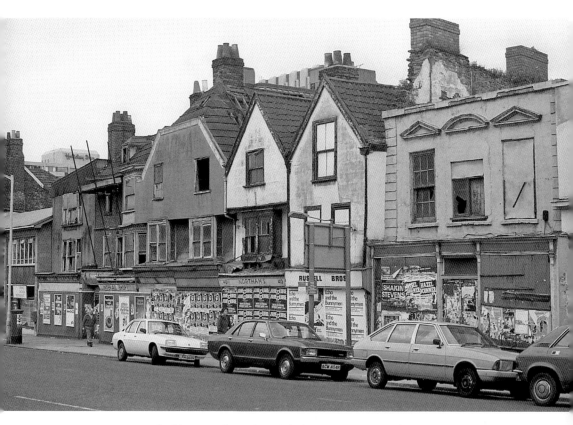

In May 1972, an attempt had been made to demolish this rank of ancient houses in Old Market Street, but was thwarted by demonstrators. A happy outcome, then, but do the buildings survive today? Well, yes and no. They were left exposed to the elements for a further decade and, by the time of the photograph, Monday 20 April 1981, were clearly beyond saving. In the following year, they were demolished and rebuilt in replica. The building on the right was an especially tragic loss: it had been a completely surviving Georgian apothecary's shop. When photographed by Reece Winstone in 1941, it had had an extra storey and hipped roof. In 1954, its bow-windowed shopfront was extant, and in 1957, the 200-year-old mahogany drawers, bottles and ointment jars of the interior were still in use. At the back was a warehouse 'with a well, old presses, barrels and a huge forged iron weigher for bulk containers'. Some of the shop's treasures, including wig chairs (high seats and low backs), were acquired by the museum. When old buildings are reconstructed or façaded, interior features are always lost. Hazel O'Connor, Shakin' Stevens, Echo and the Bunnymen and The Cure are among forthcoming attractions at the city's music venues.

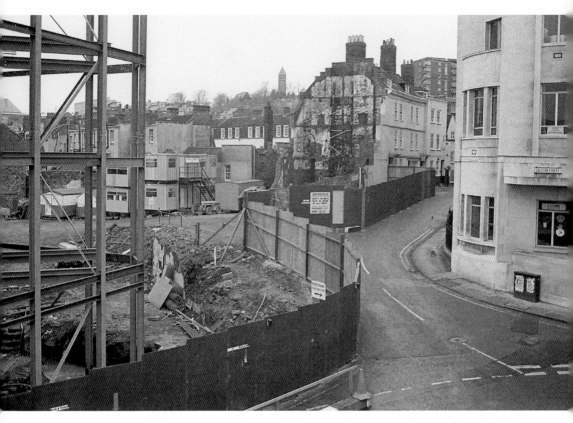

Pipe Lane, just off the city centre, photographed on Sunday 5 December 1982 from the balcony of the Colston Centre. No doubt for reasons of 'security', this is no longer accessible to the public. Off left, one of the city's most familiar addresses, Nos 1–3 St Augustine's Parade, once the head office of the Bristol Omnibus Co., was being 'remodelled'. As may be seen, the remodelling actually amounted to complete reconstruction. Perhaps it was the withering epithet 'mock-Tudor', often applied to the buildings, that sealed their fate, but behind the stick-on Victorian timbers of the frontage was a genuinely ancient structure; the timber framework and internal spaces vanished – all with the help of grant aid. Whatever might have been said against the buildings, they were a Bristol trademark, and one of the most recognised groups in the city. During my own years of servitude on the buses, the open space at the rear of the building, where the Portakabins are, was a staff car park. I remember ten-year-old bus drivers' cars parked among crumbling, buddleia-smothered foundations. On the far side were the mouldering rear elevations of early nineteenth-century warehouses with frontages in Orchard Lane. The art deco Radiant House, on the right, was demolished for the extension to the Colston Hall.

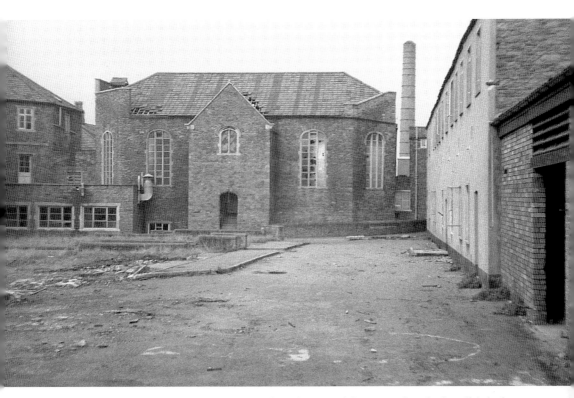

Set back from the main road in spacious grounds and screened from view by a high wall (which remains), the buildings of the former workhouse at Eastville were best appreciated from the top decks of passing buses. They were the design of Samuel Welch, who received a number of commissions for workhouses and churches in Bristol and Somerset. Locally, the establishment was known simply as '100 Fishponds Road'. It was often invoked by my mother, at times when our finances were under strain, as the place we would 'end up' if various economies were not forthcoming. On Tuesday 14 March 1972, I gained entry to the entirely deserted site by simply climbing over the wall. 'Security' had not yet been invented. The structure in the centre of the photograph was the chapel. In its later days, the workhouse had become a home for the aged. A few years earlier, at my first job, I had delivered linen here. I remember the institutional colour scheme and old men shuffling around the corridors in their pyjamas or sitting on the lavatory with the door open. To one who was young and had led a sheltered life, it was an eye-opener. The buildings were demolished soon after the photograph was taken and new housing arose.

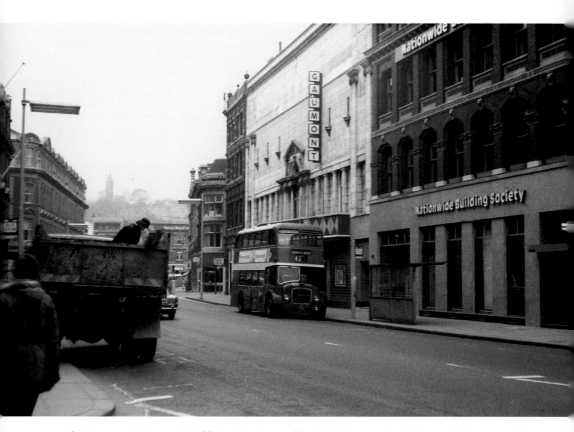

The Gaumont cinema in Baldwin Street was, like the Odeon, a Rank house. It incorporated a restaurant, which was advertised during performances. It opened as a variety hall in 1892, known as Livermore's People's Palace. It was renamed the Palace for its conversion to cinema and the New Palace with the coming of talkies. It was the first cinema I attended, in around 1955, for a showing of *Bambi*. The photograph was taken on Wednesday 17 April 1974. It must have been the school Easter holidays; a Disney double-bill was playing: *Herbie Rides Again* and *Run, Cougar, Run*. The cinema closed in March 1980, becoming a night club under various changes of name and ownership. The rear-entrance, open-platform LD-type bus on the No. 42 service from Sea Mills to Hartcliffe is probably awaiting a change of crew.

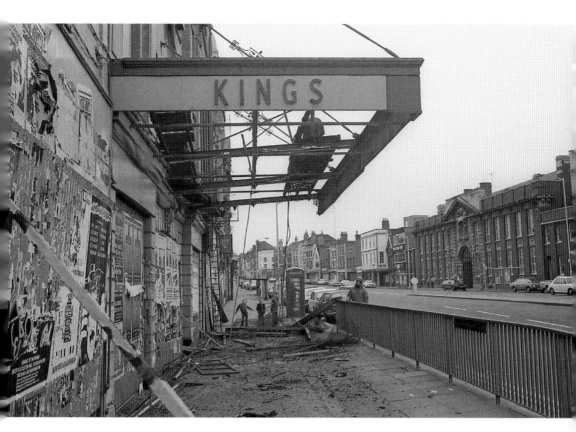

The pavement canopy of the King's Cinema comes down on Sunday 29 November 1981 as a preliminary to demolition. Health and safety does not appear to be high on the agenda. A man, unharnessed, is kneeling on a couple of boards as he cuts through the steel framework with an oxy-acetylene torch over a drop of 15 feet. Sparks fall at the feet of a watching colleague who, albeit that he wears a hard hat, has no hi-vis jacket and is standing on the wrong side of a traffic barrier. Neither cone nor hazard tape excludes the party of watching children, and nothing but common sense deters pedestrians from walking into a deluge of fiery particles. One of the boys strikes comic attitudes as he sees me raise my camera.

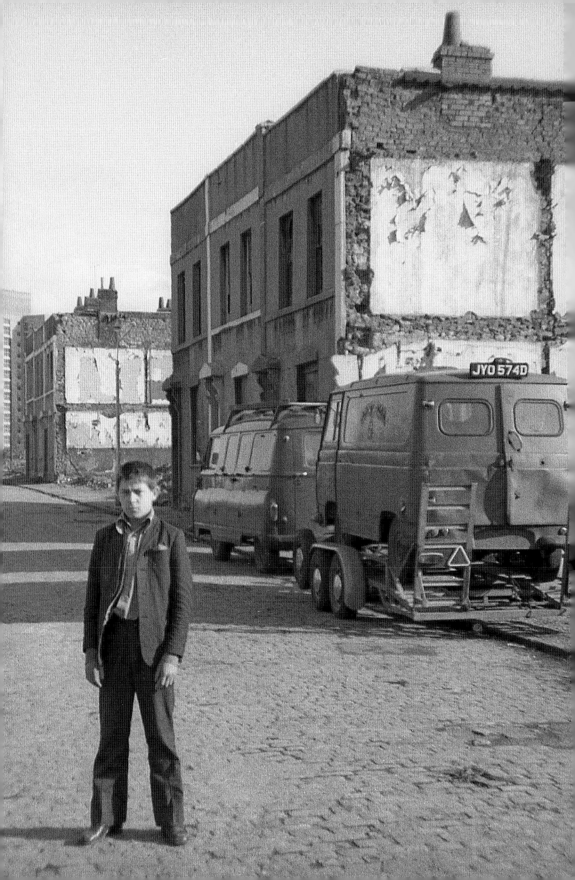

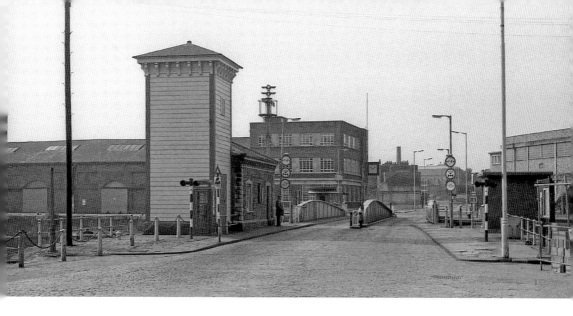

Above: Prince Street Bridge looking into Wapping Road, photographed on Sunday 3 August 1975. The vaguely Italianate timber structure houses a hydraulic accumulator for operating the bridge mechanism. Such is the volume of pedestrian traffic generated in recent years by the industrial museum and other quayside attractions, that cars are now relegated to one side of the bridge and controlled by traffic lights. The foreground is now much infested with those black-painted retro bollards that have become so ubiquitous. The telephone kiosk and antiquated level-crossing sign are gone. On the far corner, the 1930s offices of the Bristol Steam Navigation Co. are soon to be demolished. Beyond, where the Merchants Landing development would come, the left side of Wapping Road has already been cleared. The area beyond the bridge, between the Floating Harbour and the New Cut, is today often called Spike Island. The present author takes no cognisance of this term and discourages its use in others. It seems to have been coined around 1980 and presumably refers to the pointed shape of the 'island' (actually an isthmus) on a map. Place names evolve over centuries in the speech of local people; they do not derive from things seen on maps. In any case, the island was not formed until the New Cut was excavated in the early years of the nineteenth century.

Opposite: On the evening of Friday 30 March 1973, I was wandering around in Stanley Street, Easton. The few remaining houses were ready for demolition. Nearby, on one of the vacant plots, villainous undersized men were dismantling cars and vans. I heard a footfall and, looking around, saw a wild-looking boy of around twelve who ran up and joined me. He addressed me with the utmost familiarity, mauling me with hands which, I fastidiously noted, were none too clean. Seeing my camera, he asked me to take his photograph. This seemed an odd request, since he would never see the developed print. After I had taken it, he stood waiting for me to extract the finished photograph from the camera. Plainly, he had no understanding of how photography worked, although he might have heard of Polaroid cameras. When I took the boy's photo, his naturally friendly and demonstrative manner vanished instantly. He assumed a sullen expression and menacing posture, as if about to sock someone in the jaw. Clearly, he was emulating the demeanour of the television 'tough guy' – for even youngsters ignorant of the workings of cameras by this time had access to television. After the photograph was taken, he resumed his normal manner, skipping along beside me, imploring me ('come on, rich man like you') to give him some money. In his eyes, I suppose, my ownership of a forty-year-old camera made me the possessor of fabulous riches. I took a sounding of my trouser pockets and gave him 50p, probably about £10-worth of buying power in modern terms. He wrapped his arms around my midriff, gave me a tremendous bear hug and ran off to his home, a caravan parked on the rubble of a demolished house. Stanley Street was a dead end off Easton Road, but pedestrians could reach it by a little archway from Stapleton Road.

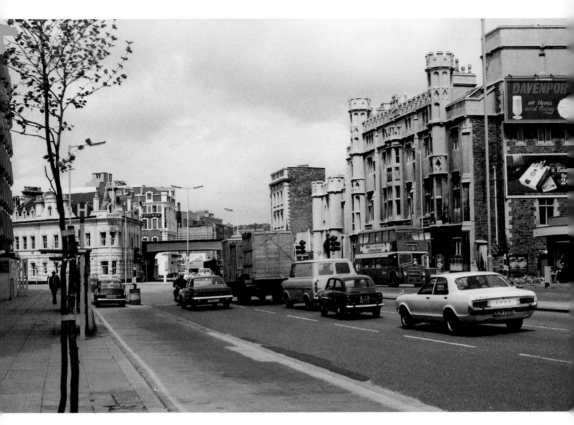

Temple Gate, Thursday 6 June 1974. Not apparent in this sunlit scene is the gale-force, grit-burdened wind that buffeted me all day and entangled my then-abundant hair into knots. A footbridge (see page 31) was due to be erected at the weekend, but the work was delayed until October. Access was by escalators in the ground floor of the recently completed building on the left. The bridge had a short life, but its blocked-up openings can still be seen in the building. Centre right is a glimpse of the little curved newsagent and tobacconist at the foot of the station approach road. The bus, on the No. 3 service from Filton to Whitchurch, is passing the neo-Tudor frontage of the original Temple Meads Station, terminus of Brunel's line from London. The bridge in the middle distance, a 1960s replacement of an earlier structure, has now been dismantled. It had once given access to the city docks. Left of the bridge is the George and Railway Hotel. The availability of draught Bass is advertised. Like the Grosvenor Hotel on the far side of the bridge, it has now been empty for many years. It is planned that both buildings will be retained in a future revamp of traffic arrangements: 24½p (with coupons) for twenty Embassy Gold.

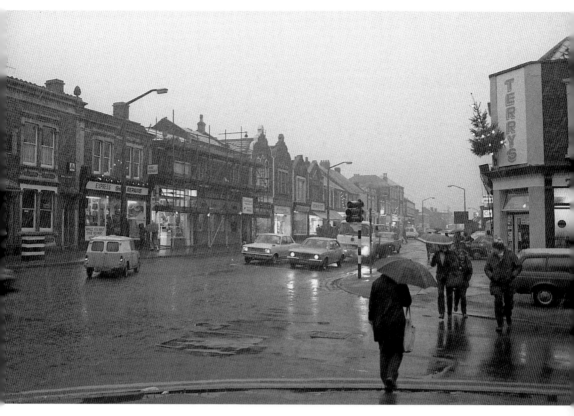

High Street, Staple Hill, seen during an afternoon downpour, Monday 21 December 1981. The heyday of the local suburban shopping centre was over, and albeit that this was Christmas week, the pavements are hardly busier than on any other day. Supermarkets had been around for twenty years, huge out-of-town hypermarkets with lavish free parking had begun to appear and every high street had been ruined by a half-deserted, wind-tunnel pedestrian precinct with a piddling fountain made from pieces of metal twisted into abstract forms. Soon would come the Americanised shopping malls and 'outlets' on the city's edge, leaving the high street to estate agents, takeaways, building societies and tanning salons. The pair of shops under the double gable had once been a branch of Stuckey's, a clothing chain with shops throughout the city. I regret to recall that I had a grudge against this blameless business, for it was the source of most of the clothes that my mother bought for me while I was growing up, which I considered unfashionable. I was surprised to get away with a pair of winkle-pickers, but I heard her remark one day that such shoes had been fashionable during the 1920s. This automatically made them acceptable to her. A pair of beige Oxford bags with turn-ups was produced and what she described as a 'nice little jersey'. The words 'nice little' lay somewhere in my stomach, smouldering. School became a suicide committed daily. One day, she came home with something called a 'car coat', suitable for a man of sixty. Its artificial fibres crackled and attracted stray wisps of hair, threatening the wearer with self static-electrocution. There were many flaming rows.

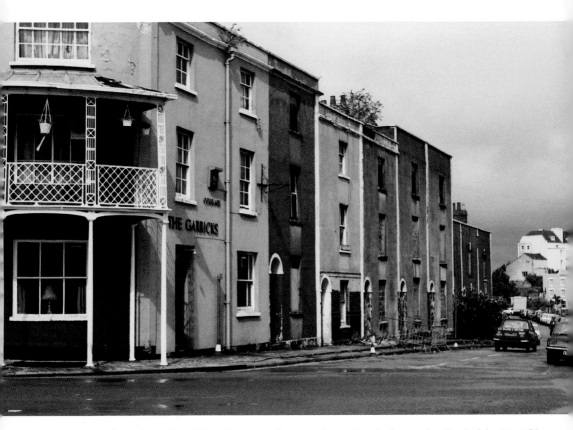

Above: The Bathurst Hotel, Wapping, was taken over in 1978 by the former landlord of the Garrick's Head on Broad Quay, who renamed it after his old pub. Its name changed again to The Smugglers, and it is known today as The Louisiana, presumably because of the fancied resemblance of its wrought-iron balconies to those seen in New Orleans. Two doors down is the tiled ground-floor frontage of another public house, The Steam Packet Tavern, now a private dwelling. The photograph dates from Friday 29 August 1980. Soon afterwards, the area suffered gentrification and the row of houses was renovated and painted in pastel colours. The usual fraudulent quayside impedimenta followed.

Opposite above: Oxford Street, Totterdown, photographed on Wednesday 7 March 1973. The left side of the street must have been felled to provide car parking for the doomed shops in Wells Road, then awaiting demolition. Smartened up, it remains a car park today. The turning leading out of the picture, bottom left, would have been Bush Street, whose short few yards, communicating with Wells Road, are now occupied by a Tesco Express, the closest thing Totterdown possesses to a shopping centre.

Opposite below: The lights come on in the tower blocks as midwinter dusk descends on Barton Hill, Friday 28 December 1973. Closer to the camera, Lawrence Hill Station had lost all its buildings and two of its platforms in a resignalling and 'rationalisation' scheme of 1970. The line had been quadrupled in the 1930s (this accounts for the doubling of the bridge across Stapleton Road), but the two extra tracks were lifted a few years after the photograph was taken. They are due to be reinstated. The flats in Barton Hill, when built, were some of the earliest and highest outside London.

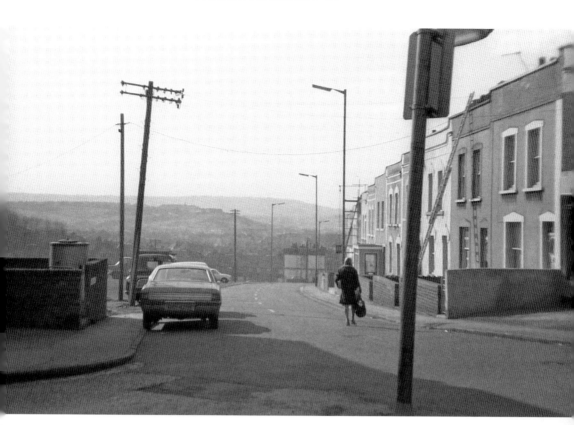

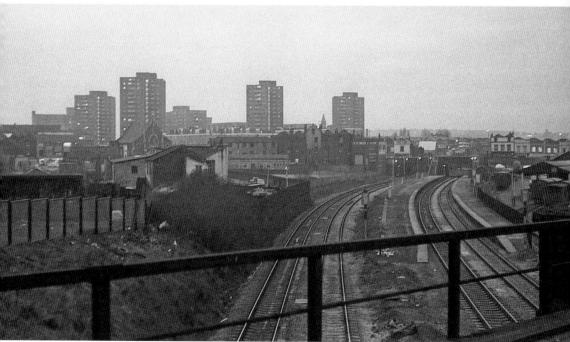

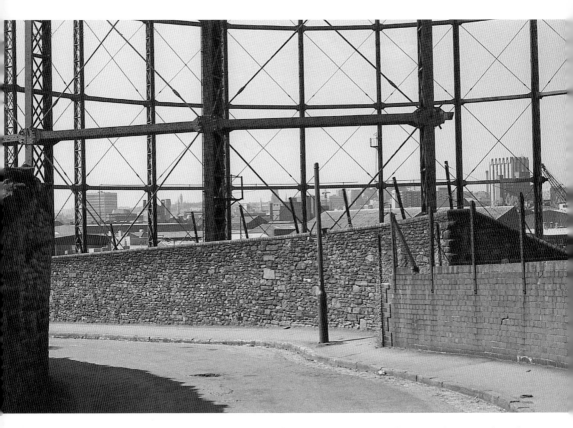

The impressive 1860s Bristol Gas Co. gasholders in Day's Road finally come down on Thursday 16 April 1981. The smaller of the two had already gone, and the first horizontal section, upper right, has been removed from its larger neighbour. We are on the bridge that carried Day's Road across the former Midland Railway line, which had closed eleven years before. The bridge, its narrow approaches and the high walls made this a hazardous spot for motorists. With the railway disused and the gasworks gone, the authorities lost no time in flattening and straightening the road, which now intersects a realigned Barrow Road somewhere just behind the camera. Today, it would be difficult to identify this spot with precision. Visible through the ironworks are some of the city's best-known landmarks, including the Robinson Building, Cabot Tower, the Wills Memorial Building, the Holiday Inn (now Marriott) and the Castlemead office block.

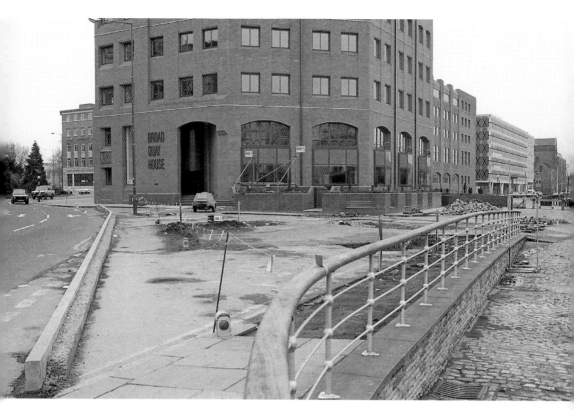

Narrow Quay is blocked off in readiness for remodelling as a quayside promenade, Sunday 29 November 1981. Broad Quay House had a difficult and prolonged gestation, evolving from a first design of 1973. The work of demolishing its predecessor, the CWS building, was prolonged and the site had been empty since 1974. I do not know the reasons for the delays, but disenchantment with the more alienating type of modern architecture was probably a factor. 'Postmodernism' had come in – an insipid updating of the Edwardian commercial style, denuded of structural decoration for the sake of tight budgets, but with a few twiddly bits added, often, as here, in the form of tubular steel or stick-on panels. In came brick facing, segmental window heads, string courses, mansards and, for some years, 'Crystal Palace' transepts of the type to be seen on the Spectrum building in Bond Street. The choice confronting architects ever since has been between the ugly, the blandly inoffensive and pastiche. As architecture, the multistorey car park adjoining the Unicorn Hotel, centre right, is more admirable. Note the paraffin lamps around the roadworks: once present in their millions, they have been replaced by cones – those sentinels of our highways – and charmless flashing beacons on tripods.

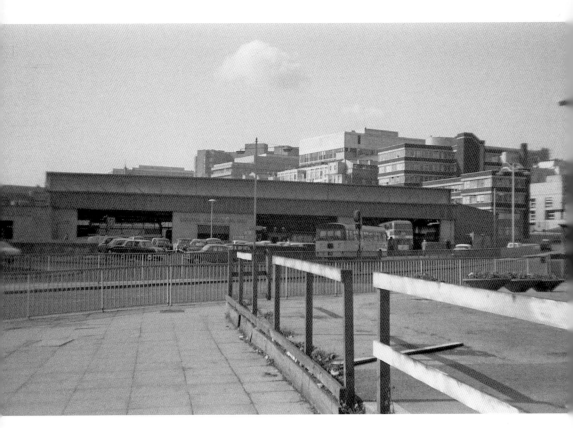

On Wednesday 7 March 1973, from close to the junction of Marlborough Street with the St James Barton roundabout, we look across to the 1958 bus and coach station. When built, it was divided down the middle by a brick wall, and there were two platforms connected by a subway. This arrangement didn't last. As well as a bus station, the building was a depot and the interior was revamped with a single platform on the left and the remainder used as parking space for the depot's vehicles. An interesting point of usage arises here to gladden the hearts of pedants everywhere: buses, which have internal combustion engines, are kept and maintained in 'garages'; electrically powered trams and trolleybuses are housed in 'depots'. Though Bristol's tram system closed during the war, the term 'depot' remains universal among the city's busmen. Bristol must have been the largest city in the country whose bus services were not provided by the municipality, and the Bristol company was unusual in owning its bus stations, depots and other properties. When, in 1986, the industry was privatised and deregulated, its shares were offered to employees at bargain prices. Finding themselves suddenly the owners of much valuable urban property, quite a few (not including the author) became millionaires. The bus station ceased to function as a depot and no longer needed the parking space. Passenger facilities remain on a much-reduced site, with lucrative, rent-earning offices above. The rest of the site became the city's new magistrates' court.

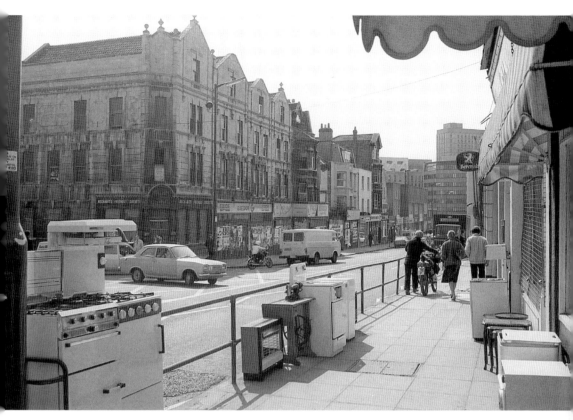

Stokes Croft, seen here on Thursday 9 April 1981, boasted many shops trading in second-hand furniture and kindred goods. A year or two later, setting up home in my 'first-time buy', I was grateful for their humble, but useful, services. I would like to think that somewhere among this assemblage of 'white goods', there reposed a Tricity Tiara electric cooker – the contemporary flat-dweller's friend. The cooker, second from left, with the new-fangled push-in knobs and modish eye-level grill, would have been a good bargain. Also visible are a gas fire, nest of tables and a treadle-powered sewing machine. A Ford Escort, with replacement offside front wing, noses out into the traffic from City Road. The four-gabled building beyond the corner was condemned, and notices proclaimed it to be a dangerous structure. It was demolished in April 1982 and replaced by an edifice of three storeys in Tango-coloured bricks with a similar gabled roofline.

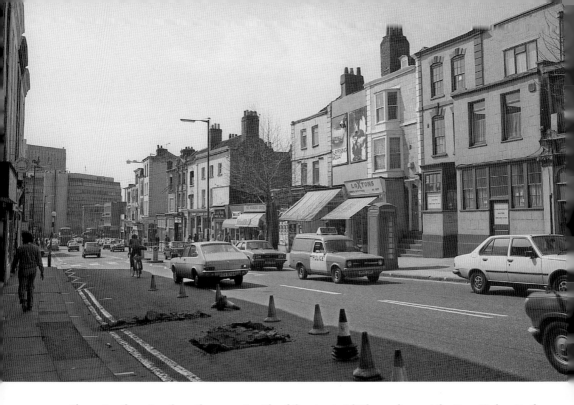

Above: Another view, from the opposite side of the street. A little rundown at the time, Stokes Croft was soon to become a conservation area, and there would be no place for such 'out-of-keeping' details as advertisement hoardings or mid-century canvas shop blinds. The engaging, unplanned shabbiness we see here was intolerable to the official mind. In future, the area was to be stamped with the bureaucratic idea of authentic appearances, notwithstanding official connivance at spuriously subversive 'street art'.

Opposite above: Excursions along the Bristol Channel coast aboard P & A Campbell's 'White Funnel' steamers were a fixture in the reminiscences of older Bristolians when I was a boy. Photographs of the vessels remain a staple of old postcards and 'as it was' books. The trouble is that as you get older, it becomes increasingly difficult to distinguish what you remember from what you've been told to remember. I vaguely recall being told that I'd been on one of the steamers as a boy. The final season was 1960, so this is possible. On Wednesday 20 February 1974, the landing stage was still substantially intact and its buildings, as far as one can judge from the photograph, in good order. Pre-war, and before the Portway was constructed during the 1920s, the facilities were served by the tram service, which terminated at the foot of the Clifton Rocks Railway, a few yards off left. This must have been quite an important transport interchange and a more animated place than now. Today, the entrance building, with its hipped roof and the little booth, are gone and the landing stage is derelict. The traffic moans past.

Opposite below: Redcross Lane, an alley off the top of Old Market Street, was looking a little distressed when photographed on Monday 22 December 1980. Today, the setts are still in place, but all else is gone. The interesting selection of contemporary motors, probably associated with the business on the left are, I think, a Ford Granada, Ford Escort, Vauxhall Viva, Triumph Herald, BMC Mini and a Mk I Vauxhall Cavalier.

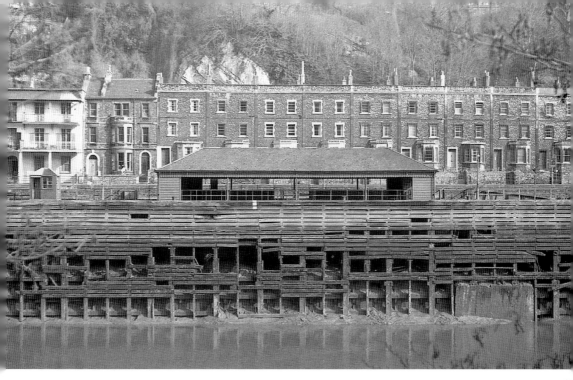

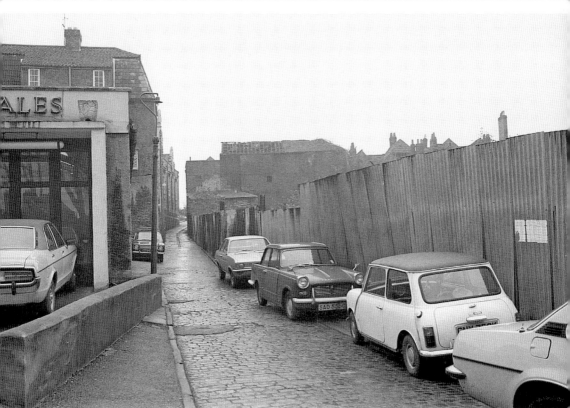

Looking down the slope of Newgate, Saturday 20 April 1974. In the right distance, the Holiday Inn has recently opened; it became a Marriott in 1988. Directly ahead, in Lower Castle Street, are the lift shafts of what became the Castlemead building. The completed building was not occupied until 1981. On the left is the blue mosaic of the Fairfax House department store, whose demolition for the Galleries shopping mall afforded Bristolians a long-running spectacle during 1988. The 1100 turning across the traffic will pass through the building and cross Fairfax Street in an enclosed bridge to reach the multistorey car park behind Broadmead. The current Galleries car park has an entrance in the same position. Some thirty-four years after it was destroyed, the site of the pre-war shopping centre is being landscaped and seeded and would eventually become Castle Park. As late as the early 1980s, disturbance of the ground re-exposed the footings and basements of bombed shops. It was summer. As a driver working from the bus station, I sometimes wandered over in the evenings during my meal breaks and trespassed among the excavations. On one occasion, I descended a flight of steps and found a pencilled graffito, dated 1921, on the whitewashed wall of a cellar.

Looking from Tower Street into Church Lane, Temple, Thursday 9 April 1981. Temple Way is just behind the camera, and the distant buildings are in Victoria Street. In those days, any recently cleared demolition site seemed to become a short-term NCP car park. Today, low-rise office buildings, of a type indistinguishable from Inverness to Truro, built from pastey-faced, relentlessly durable, never-to-mellow, mass-produced bricks from Bedfordshire, occupy the empty plots and the Novotel is off left. The stone setts of the road surface remain, but the picturesquely uneven flagstones have gone.

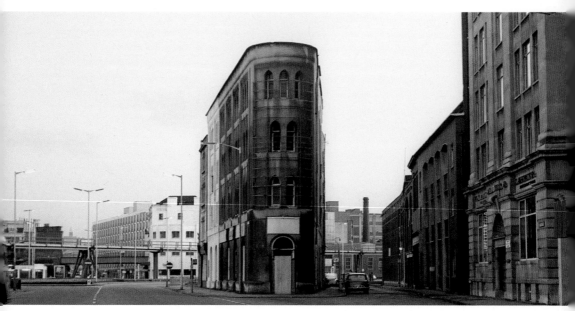

Another of Victoria Street's sharply angled junctions, photographed in failing light on the afternoon of Saturday 1 February 1975. The framework of a long-vanished advertisement hoarding (M&B – it's Marvellous Beer?) remains on the rounded corner. Every fashion in taste is followed by a reaction, which takes a generation or two to run its course. At some point in its life, as Victorianism fell out of favour, the building was coated in cement render. This was thought an improvement. As dereliction set in, the render began to flake off, revealing small patches of polychrome brick at the roofline. Perhaps, I was the only person who noticed it. In due course, the taste of our grandparents came once more to be esteemed, and Victorian architecture was back in. Had it lasted a few years longer and more of the underlying brickwork been exposed and noticed, the building might have survived to enjoy restoration, like the Talbot Hotel at the opposite end of the street. It finally came down in December 1980, and the site has been an empty triangle of grass ever since. The distant industrial buildings were part of Mardon, Son & Hall, a giant of the printing and packaging business, closely allied to the city's tobacco industry. Always known simply as 'Mardon's', and a large employer in the city, its congeries of buildings spread over a large site south of Temple Gate. In the middle distance, a look at the temporary (1967–98) prefabricated 'Meccano set' flyover, which took traffic, in one direction only, from Temple Way to Redcliffe Way. It was replaced by the box junctions, lanes and massed traffic lights of the Temple Meads 'gyratory'.

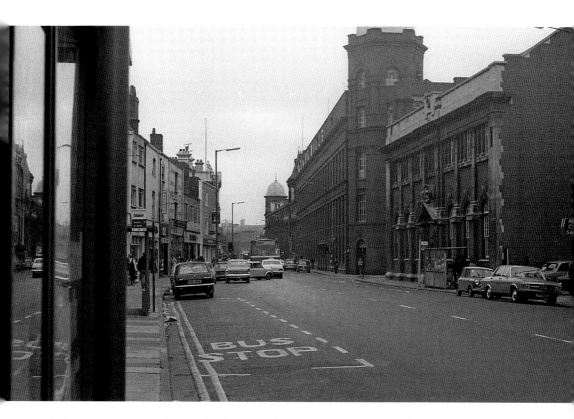

Bedminster Parade, Saturday 25 October 1975, looking into East Street. The first building on the right was Bedminster Library; beyond are the W. D. & H. O. Wills cigarette factories, which dominated the life of south Bristol and were probably the city's largest employer – Rolls-Royce, B. A. C. and Fry's being the likely runners-up. The library and factories alike were designed by Frank Wills, a cousin of the tobacco family and their in-house architect. He designed not only their factories but also their country houses and the buildings of philanthropic Wills-funded undertakings, notably the museum and art gallery in Queens Road. Bristolians of a certain age will remember that the factories were inundated in the disastrous floods of July 1968 and countless millions of cigarettes dumped on a site at Avonmouth. Many of these, condemned but for practical purposes undamaged, found their way into the pockets of the city's smokers, for whom it was a golden time. Cigarette production was due to transfer to a lavishly equipped new factory at Hartcliffe that, in the event, barely outlived the buildings it had replaced. The closest of the factory blocks made way for an Asda supermarket; the other is now an arcade of shops.

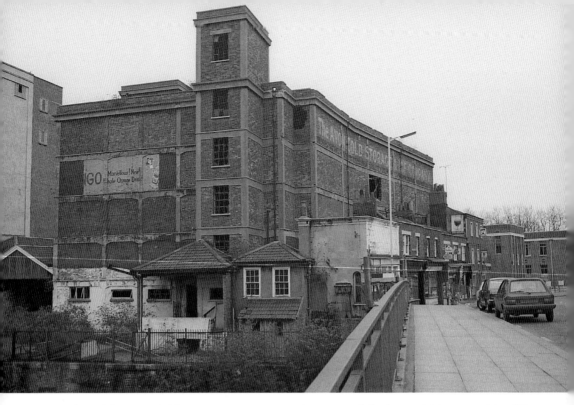

Above: 'The Avon Cold Storage & Ice Company' announced the letters high up on this edifice of ferro-concrete and brick, seen from St Philip's Bridge on Sunday 29 November 1981. Such a structure, not adaptable to modern warehousing practice and standing on valuable city centre land, was obviously doomed. It had been empty and derelict for years. 'Good riddance', most people would say, and certainly the building was no beauty; yet, it left one in no doubt that it provided a useful function in the life of a no-nonsense working city. It has given way to an insipid development of 'apartments' and offices – the former paid for in fantasy money earned from non-jobs in the latter. The public house and row of shops in Passage Street survive. They had once continued around the corner into Tower Hill, modestly prospering at the periphery of the main Castle Street shops. The little building with the pair of Georgian sash windows, bottom centre, remains, but its lean-to outbuilding went to make way for a harbourside path.

Opposite below: Another flat-iron junction, this one made by the intersection of Victoria Street with St Thomas Street. Until a few years before, the triangular corner plot had been occupied by an elegant building belonging to the Iron & Marble Co. Ltd. The crass, squared-off structure at the right edge was its replacement. No modern building seems capable of turning a corner elegantly. The group of four-storeyed, jettied buildings on the left dates from 1673; the earlier date displayed on the frontage is inaccurate. The photograph was taken on Monday 23 June 1975. The buildings in Victoria Street await the restoration and façading that would come to them twenty years later. An engaging line-up of contemporary cars, the closest of which are a Morris Oxford Estate (left) and a Hillman Avenger. How quaint the chromium-plated wing mirrors, on their little stalks, now seem.

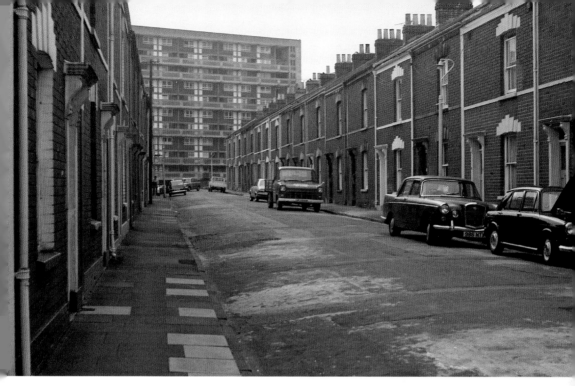

Above: Granville Street, Barton Hill, Saturday 20 April 1974. Remarkably unchanged, it came unscathed through the 1980s vogue for stone cladding and is untouched by that most offensive of building materials, pebble-dash. Ecclestone House, the block at the end of the street, has suffered no more than a light facelift. The main changes have been plastic windows, wheelie bins, a decrease in the availability of kerbside parking space and the substitution of low-maintenance asphalt for flagstones.

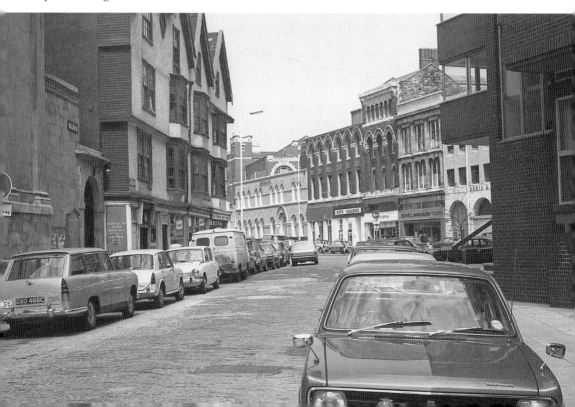

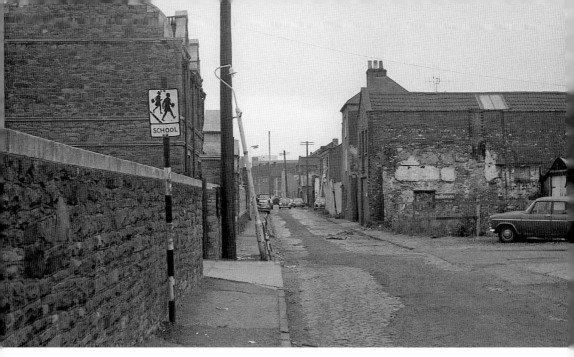

Above: Stillhouse Lane, Bedminster, photographed on Saturday 25 October 1975. The 'school' sign, minus its red warning triangle, is of a design dating from 1957, which replaced the earlier 'torch of knowledge' version. Affronting political correctness, the boy is a little ahead, striding purposefully forward with chin up; the girl brings up the rear, toddling along to keep up. With its leaning lamp posts, uneven, flattened kerbs, littered gutters, scruffy bits of unadopted ground and untidily patched setts, Stillhouse Lane was a place where the imagination could speculate and dream. Today, we would find ramrod-straight kerbs, perpendicular lamp posts, smooth asphalt with yellow lines, new apartments, lashings of masonry paint and not so much as a dandelion peeping from a crevice.

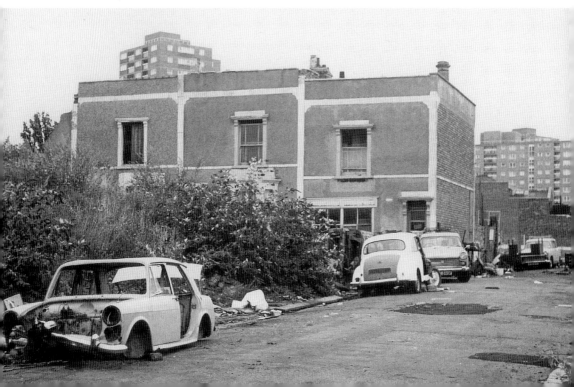

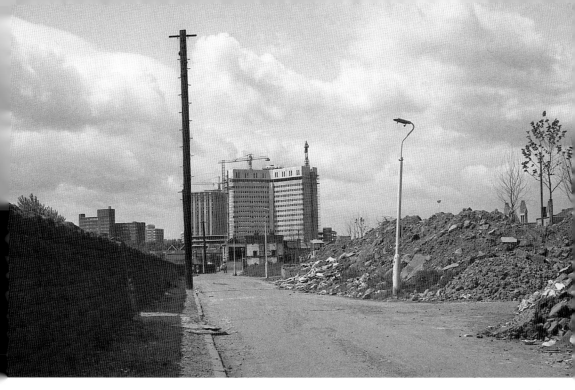

Above: Wellington Road, Sunday 1 June 1975. Cowley Street joins in the right foreground and St Agnes Road a little further along. Over the wall, left, is the drop into the tyre and shopping trolley-crammed waters of the River Frome that, a few hundred yards further along, vanish underground to reappear, a mile downstream, from under the city centre. Tollgate House, which was eventually occupied by government offices, is nearing completion; it was demolished in 2006. A little further away, the Castlemead building is nearing completion. Though they were not directly in its path, the houses had been demolished as part of the work for Newfoundland Way, the dual carriageway extension of the M32. The rubble was later bulldozed into tasteful contours and seeded to become Riverside Park. Today, the saplings are mature trees.

Opposite below: Strode Street, Barton Hill, Thursday 1 September 1977. The turning on the left, where the houses stood, would have been Meyrick Street. Derelict cars visible are a BMC 1100, two Austin Cambridges (or variants thereof) and an Austin A40.

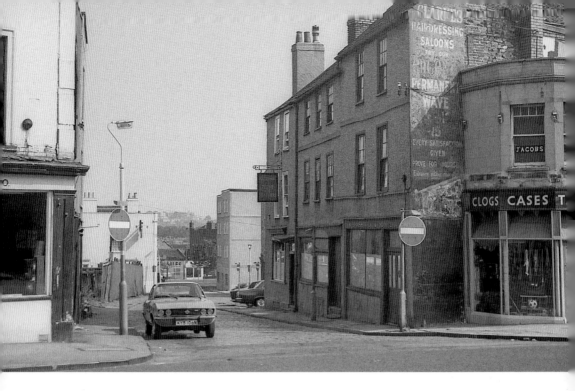

Above: Gloucester Lane, off West Street, Old Market, seen on Sunday 3 August 1975. The Plume of Feathers pub became, in the final years before its closure, The Old Castle Green. The building survives, but the other two in the rank were rebuilt as flats. To my inexpert eye, all look like Georgian refacings of earlier timber-framed houses. The corner property was also reconstructed, but the shopfront, being listed, was preserved as a façade. Clogs are advertised and had been made here until the 1950s. Clarke's hairdressing saloons advertise permanent waves at 15s. In the nineteenth century, Gloucester Lane was an alley of low dives. About where the corrugated-iron fence is, halfway down on the left, a police constable was murdered after remonstrating with a man for ill-treating his donkey.

Opposite above: The modest, almost domestic, accommodation provided for the boys in blue, Sunday 1 June 1975. Trinity Road police station was demolished in 1977 and replaced by an inscrutable, doorless, windowless, inward-turned barracks, more appropriate to the era of total surveillance, administrative detections, enforcement cameras, body armour, high-powered pursuit cars, Tasers and Heckler & Koch semi-automatic sub-machine guns.

Opposite below: There was nothing a planner liked more than to unroll a map, spread out a sheet of talc and, leaning forward with the earnest mien of the public benefactor, to apportion whole districts into differently coloured areas, each representing a different 'land use'. Easton was designated a Comprehensive Redevelopment Area (CRA), but Brixton Road escaped by a hundred yards when the planner's chinagraph pencil traced the boundary along nearby Bouverie Street. On Sunday 1 June 1975, it remained an authentic survival, little changed, apart from the parked cars, from the Easton of the immediate post-war era. During the 1990s, the traditional light-olive-coloured render, sometimes incised to mimic ashlar, succumbed to overpainting in pastel hues. This fad broke out like a dermatitis all over Bristol, especially on the slopes of Windmill Hill and Hotwells, turning Bristol poetry into pseudo-Mediterranean prose. Mercifully, the fashion seems to have run its course, but once painted, the original colour is lost and the only course is further repainting. Note the converted gas lamp in the foreground, complete with ladder rest.

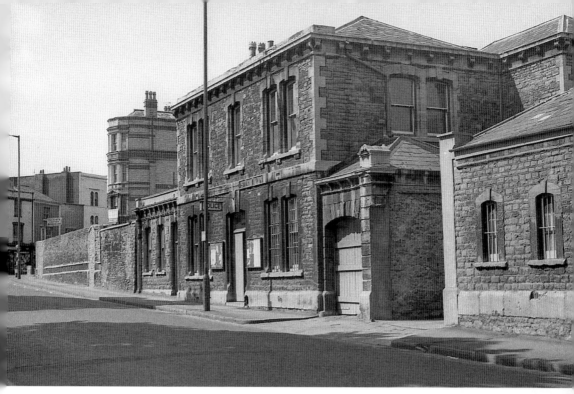

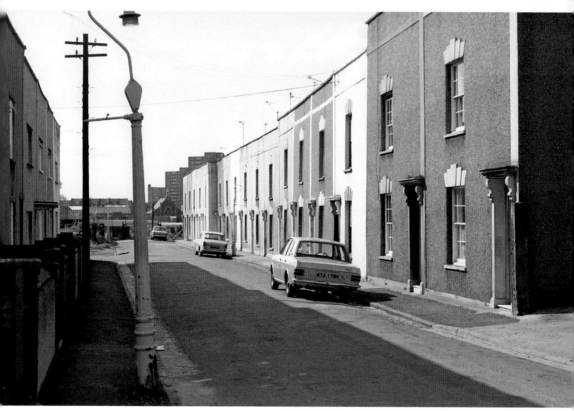

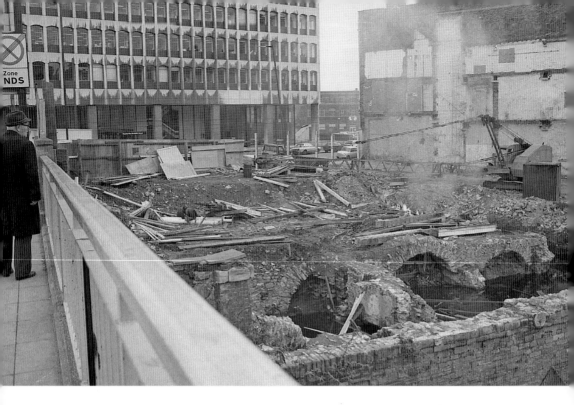

Above: Archaeological excavations in progress, Thursday 12 November 1981, among what were to become the foundations of a new office building modishly named One Victoria Street. In the background is the Robinson Building which, spruced up and converted to flats, became One Redcliff Street. This plot had been empty since the war and had been known to a former generation of Bristolians as 'Fear's Corner' after the shop on the Redcliff Street turning.

Opposite above: Where are the swooping flyovers and elevated slip roads? Where are the orderly lanes of traffic, merging, dividing, in and out, over and under? It is sometimes difficult to escape the conclusion that the planners had spent too much time at the cinema or watching television cop shows and had become besotted with the image of America. In thrall to a fantasy of soaring skyscrapers and multilevel highways, they attempted a home-grown version in poor old Britain. What we got was a naff, provincial, misunderstood version of a foreign manner: instead of Manhattan, we got the Barton Hill flats; our San Diego Freeway was the Cumberland Basin; we took Los Angeles and made it into Milton Keynes. On Friday 5 March 1982, nearly a decade after the clearances in Totterdown, the area looks more barren than ever for having been smoothed out and grassed over. The nicely turned-out lady waiting for the bus to take her shopping in Bath contemplates an appropriate monument to the post-war planners' empty, sterile daydream.

Opposite below: At the Three Lamps junction, the bare triangle of ground, bottom left, keeps alive the memory of the little flat-iron building seen on page 29. Today the reinstated turnpike signpost, embellished by three dubiously authentic lamps, stands on the plot. An Invacar three-wheeler invalid carriage waits at the lights. Concerns about stability led to their disappearance. Three banded traffic light poles, with hooded lenses, suffice where currently twelve are necessary.

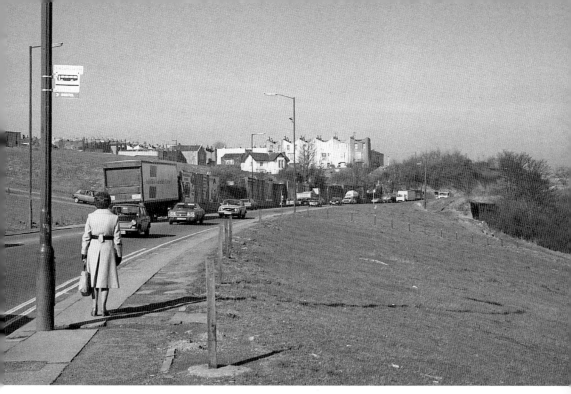

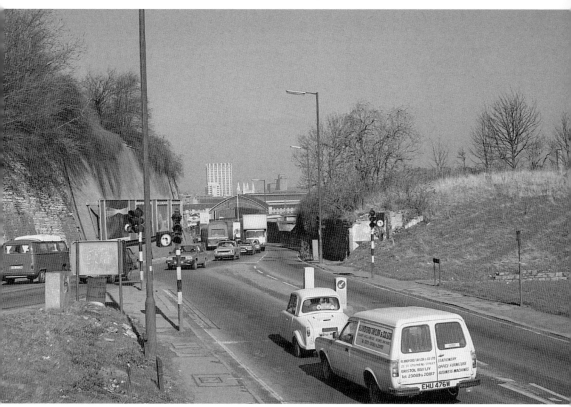

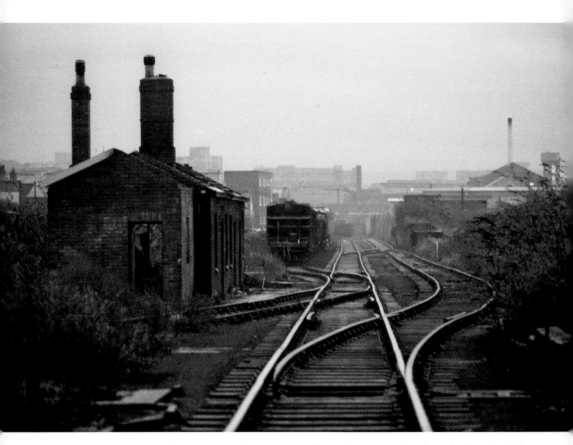

Seen on Sunday 3 February 1974, this must have been the very earliest bit of railway laid down in the Bristol area. It opened in 1835 as part of a horse-drawn tramway that brought coal from the south Gloucestershire collieries to a wharf at Avon Street. The dock, then at the edge of the city, from which coal was loaded onto barges, was known as Cuckold's Pill being, presumably, a popular trysting place. In the 1840s, the tramway's route from Westerleigh to St Philips was widened to become part of the Bristol & Gloucester Railway, which eventually passed to the Midland Railway. The Midland, thereby, gained access to Bristol's port, much to the annoyance of the Great Western Railway. Since Midland Wharf, as it became known, was upstream of Bristol Bridge, it was inaccessible to seagoing vessels, and all materials had to be trans-shipped in a fleet of barges owned by the railway. Midland Wharf was used until the early 1980s by the Blue Circle cement company; those must be some of its wagons in the siding on the left. The portion of track seen here continued in use by trains on lowly refuse disposal duties, known as 'the Binliners'.

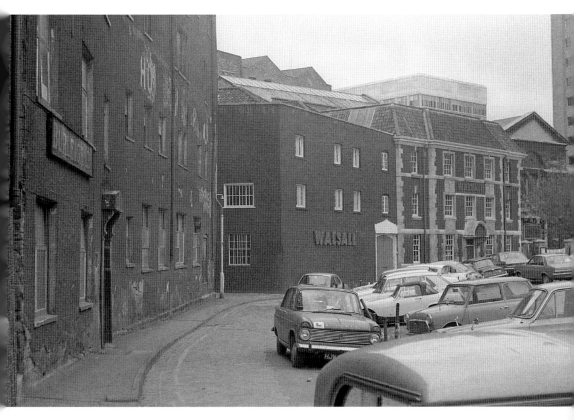

Narrow Lewins Mead, when photographed on Saturday 25 October 1975, gave a faint impression of the appearance of its continuation, Lewins Mead, before the latter was widened and all its buildings demolished for the Inner Circuit Road. The closest building, of seventeenth- and eighteenth-century origin, heightened in the nineteenth, was occupied by a printing firm, Burleigh Press. Its frontage is notable as a particularly fine and nicely distressed example of 'Bristol black' roughcast render, which once did so much to determine the look of the older parts of the city. It was lost in 1984, and the St Bartholomew office development came in its place. The Walsall Engineering buildings are now an upmarket hotel. The more distant, apparently Georgian, building with the shell-hood porch dates from 1922.

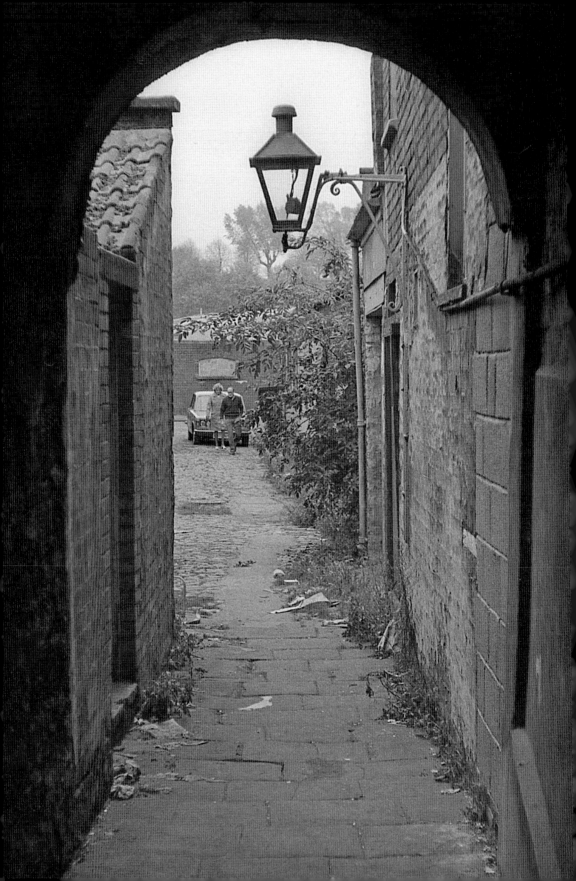

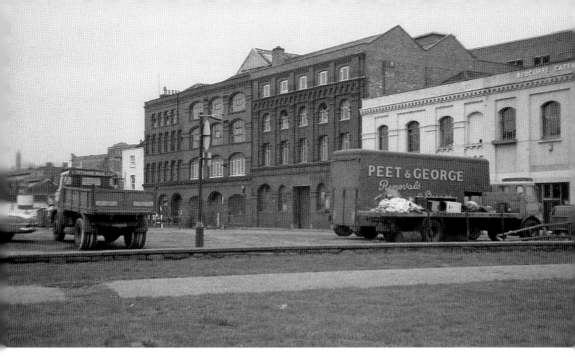

Above: Warehouses in Portwall Lane, Redcliff, Saturday 3 March 1973. The red-brick buildings remain, converted to other uses and scrubbed to the colour of orangeade. Old buildings should not be cleaned: the practice is comparable, in its barbarism, with sandpapering the patina from antique furniture. The lighter building on the right, behind the Peet and George pantechnicon, has since disappeared. The lorry on the left belongs to the Cattybrook Brick Co. Ltd. In all probability, the warehouses, like much of Bristol's Victorian fabric, were made from the products of this firm, established alongside the South Wales Railway when, during construction of the tunnel at Patchway, the fine quality of the clays was noticed. In 1973, the company was on its last legs. By August, it had shut down and all its chimneys and kilns, on the slope below Almondsbury, had been felled.

Opposite: Bedminster Place, off Stillhouse Lane, ends in this passageway communicating with the shops in Bedminster Parade – and, these days, the Asda supermarket. It used to be known, informally, as Woodchoppers' Court. The lane was lined with hovels. In an early example of recycling, the womenfolk collected scrap timber from local businesses, broke it down into small pieces and hawked it around the streets as firewood, carried on their heads in baskets. A 1902 photograph shows this industry in action. The gas lamp and its bracket have gone. The brickwork beyond the arch is admittedly no great loss, but even modern bricks are preferable to render and masonry paint. A ferocious scorched earth policy now banishes every dock leaf and blade of grass from fissure and cranny.

Walcot Street, a turning on the south side of Newfoundland Road, turned a 90-degree bend when it encountered the Frome and, becoming Wellington Road, followed the river all the way to Broad Weir and the Broadmead shops. The last two houses in Wellington Road were still standing when photographed on Sunday 1 June 1975. Entering the picture, bottom left, is the footpath from Lower Ashley Road. All this was lost when the M32 was constructed. The path, now much wider and overhung by umbrageous boughs, has become part of the Frome Valley Walkway. The river, off left on the other side of the wall, is today much more impeded by vegetation. During my lifetime, like all rivers and streams in the Bristol area, it has been heavily colonised by that invasive plant, Himalayan Balsam. Keep your eyes peeled, and you may spot that imposing, officially persecuted monster of the parsley family, giant hogweed.

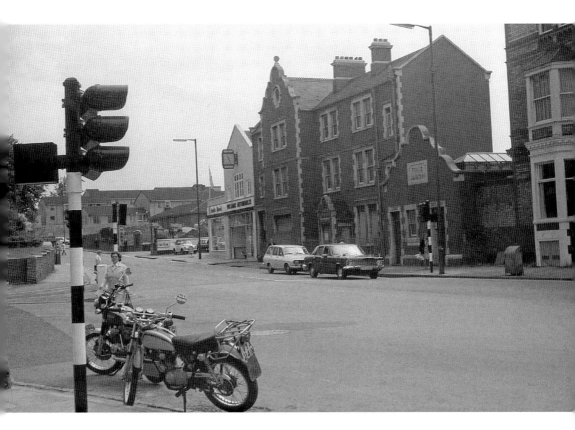

Eastville Junction, where Fishponds Road met Stapleton Road, was at one time a fiendishly busy traffic intersection. Long tailbacks formed in one direction or the other during the morning or evening peaks. A cinema, two large public houses, a bank, police station, public convenience, undertaker and a variety of well-patronised shops had collected around the junction. The M32 drew off all but local traffic, and the area's decline began. Just behind the camera had been a turnpike toll house, occupied in its final years by a tiny florist's shop called Edith's. Toll houses were, of necessity, close to the road and became more so as widenings took place. If the M32 had come a few years earlier, it might have saved the shop from being demolished by a lorry in 1969. I took the photograph, on Monday 23 June 1975, because I'd seen that the police station was boarded up and assumed it was to be demolished. In fact, all of this group of buildings survive: the police station is divided between three businesses, and the public convenience is a pharmacy. What didn't survive were the brand-new houses in the distance, built on the site of the Eastville workhouse. These have since been replaced by flats. Unlike most public clocks in those days, that on the Williams Automobiles building kept time with the utmost fidelity.

I wonder how many businesses around Bristol during the 1970s named or renamed themselves after the Concorde aeroplane. All, I suppose, hoped to link their reputations to that of Britain's white-hot technological wonder. This was Concord Motors, in Monk Street, off Newfoundland Road, and one can't help being aware of a certain unsuitability. There was, to say the least, a marked disparity between the supersonic Anglo-French aeronautical miracle and this backstreet sraightener-out of dented mudguards. Hats off to the proprietor though for his unwillingness to adopt the Frenchified spelling, with the final 'e'. This was a contentious matter for some years, but Anthony Wedgwood Benn (he had not yet completed the process of proletarianising his name to the irreducible 'Tony Benn') as Minister of Technology (and a local MP) decreed, as we all knew he would, that the French form should be used. This location, photographed on Sunday 1 June 1975, would now be underneath the surface of Newfoundland Way.

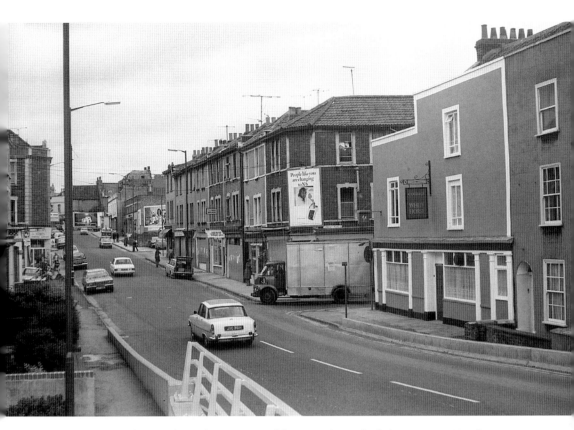

Lower Ashley Road, seen from the new roundabout at the end of the M32 on Monday 29 September 1975. Of the rank of shops in the centre of the picture, all but three are boarded up. I would conjecture that these properties had been acquired by the council with a view to demolition for the Outer Circuit Road. Too costly to renovate and unworthy of 'listing', they were demolished not long afterwards even though the road scheme had been cancelled. A petrol station was constructed on the site – a type of building that is always an eyesore – probably with high hopes of trade from the motorway. In the event, only light local traffic joined here, and the garage did not last long. The rank at the left edge was also demolished, and its site has been an empty patch of grass ever since. The ironmonger's shop on the corner of Tudor Road has since prospered as a Chinese emporium.

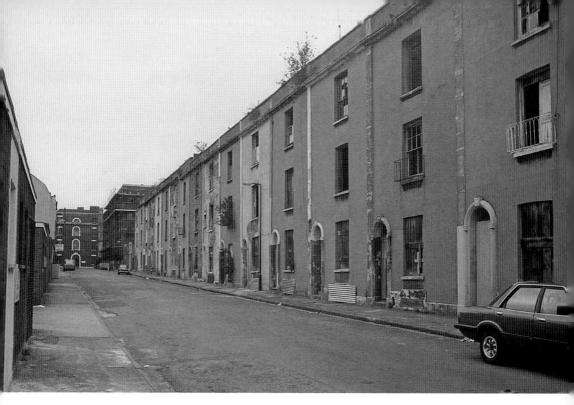

Above: A handsome three-storey terrace of the 1830s in Wilson Street, St Paul's, seen in April 1981. Presumably, all would once have possessed the pretty first-floor railings of the closest two houses. Only three remain here. The 'coal holes' communicating with cellars are sealed with corrugated iron, and a substantial buddleia bush reaches for light from an upper window of a house in the middle of the terrace. The houses were renovated and remain standing, though today they appear to rise from a plinth of parked cars. A bogus modern terrace of flat-topped, pavement-edge houses, in imitation of the Easton style, now stands on the left side of the street. On the right, at the far end, is the red-brick former boot factory of 1895, now converted to flats and excruciatingly renamed Portland Lofts.

Opposite below: Few outsiders, and by no means all Bristolians, are aware that the city and its surroundings were, within living memory, a working coalfield. Church Farm Colliery, Mangotsfield, was a shallow dead-loss affair. The pumping engine house, seen here on Saturday 10 December 1981, dated from a deepening of the shaft in 1881. The mine closed about ten years later. At the time of the photograph, a date stone reading 1880, had recently disappeared, probably stolen. Deep mining was still taking place at Speedwell, only a couple of miles from the city centre, in 1936; it ceased at Coalpit Heath in 1949 and at Radstock in 1974. A post-war drift mine operated unprofitably near Filton until 1963. During the 1990s, these anonymous acres of farmland on the city's rim disappeared forever beneath new housing. The development took its name from Emerson's Green, a scattering of cottages at the end of a lane off left of this view. Repointed, topped with coping stones and stripped of its ivy, the engine house was retained as a 'feature' and stands on a little plot of grass among starter homes, conservatories and Leylandii hedges.

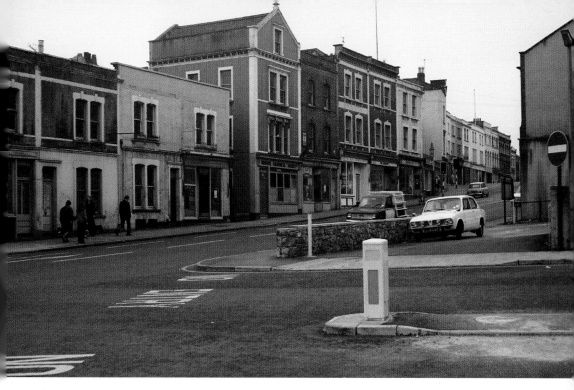

Above: Upper Maudlin Street, Saturday 20 April 1974. Many of the buildings were empty and becoming derelict. The terrace of four on the left was eventually demolished and made way for an addition to the Bristol Royal Infirmary complex. The four-floored building in the centre (was the attic storey an addition?) and all to the right survive, somewhat smartened up, to the present day.

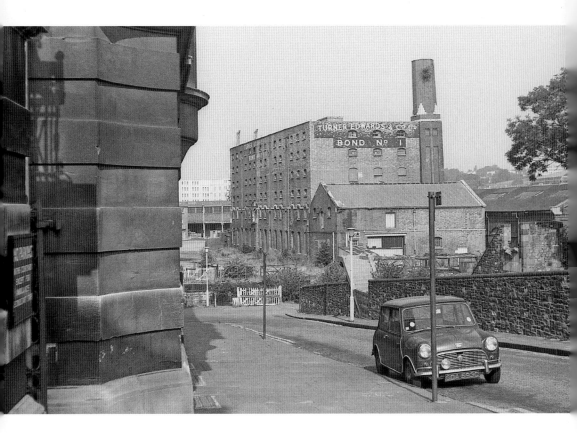

The view down Guinea Street, Redcliff, from the entrance of the General Hospital, Sunday 3 August 1975. The huge Turner Edwards Bond No. 1 had, in recent years, suffered the loss of its pitched roof and the reduction of its chimney. The smaller building at this end was its boiler house. On the other side of the wall, right, had been the drop to the railway line linking the city docks to the main line at Temple Meads. Behind the camera it entered a tunnel beneath Redcliffe Hill and part of St Mary Redcliffe's churchyard. The line closed in January 1964. Demolition of a footbridge has left a flight of steps leading nowhere. Beyond the Turner Edwards warehouse is a glimpse of the tobacco bonds at Canon's Marsh, felled by explosives at seven o'clock one morning in May 1988 as I sat up in bed bottle-feeding my eldest son. The Turner Edwards building went in 1981, and the site was cleared for the Merchants Landing development.

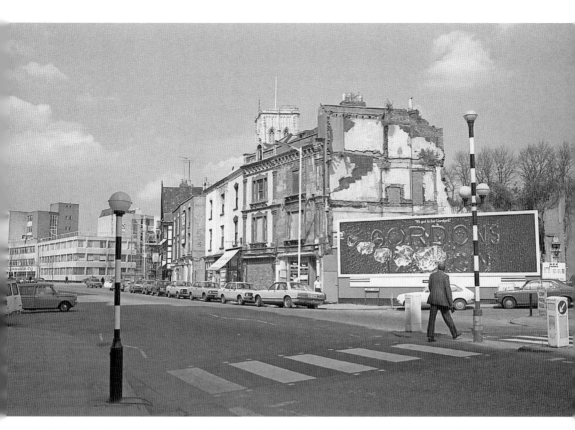

Looking along Victoria Street, Thursday 9 April 1981, with Cart Lane joining from the right. Today, it is difficult to be sure of what is genuine and what is fake. The first two properties after the advertisement hoarding seem to have gone, but the group of three beyond them has somehow become four, complete with railings – an ignorant faux pas, since there are no basements into which incautious passers-by must be preserved from falling.

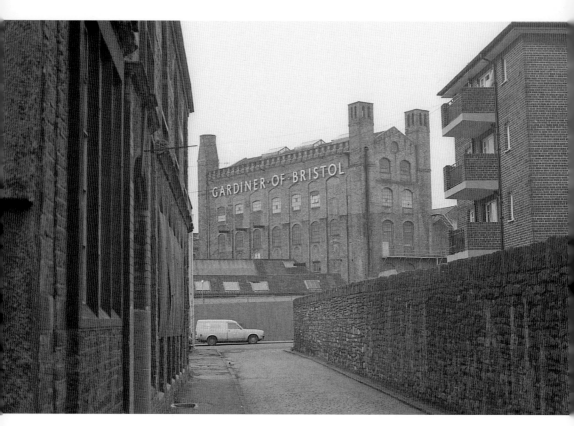

The most striking of the complex of buildings grouped around Broad Plain once belonging to Thomas's soap works. The business became part of the Lever empire and soap-making continued until 1953. It is thought our old friend W. B. Gingell may have carried out a remodelling of the building in 1881. A fire of 1902 resulted in the reduction of the turrets and the loss of much decorative detail. The current owners are to be commended for their retention of the excellent lettering following the business's change of name to Gardiner Haskins. The Morris Marina van is parked in New Kingsley Road. Of Kilkenny Street, only a vestige remains at the far end. The building on the left has gone, only fragments of the old walls remain, and the flats on the right appear to have been grafted onto a new block. As so often, this view would now be obscured by substantial trees. Photograph taken on Sunday 29 November 1981.

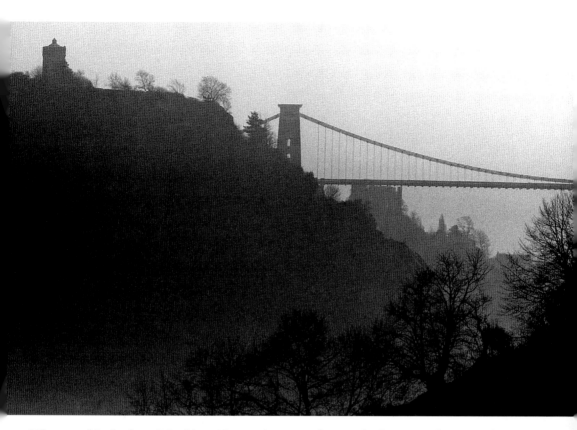

Where would a book on Bristol be without at least one photograph of its great showpiece, the Clifton Suspension Bridge? In this view, taken on the afternoon of Wednesday 20 February 1974, we are looking across at the Observatory, on the Bristol side of the Gorge. We went in once, but not finding an attendant, my mother attempted to operate the camera obscura herself. She reached up and flourished a tiller-like handle, apparently connected to the optical apparatus in the roof. The circular, slightly concave, screen around which we were grouped remained obstinately blank and we departed, believing that we'd broken the venerable instrument. I think I took the photograph from one of the steeply inclined rock faces on what I still think of as the Somerset Bank.

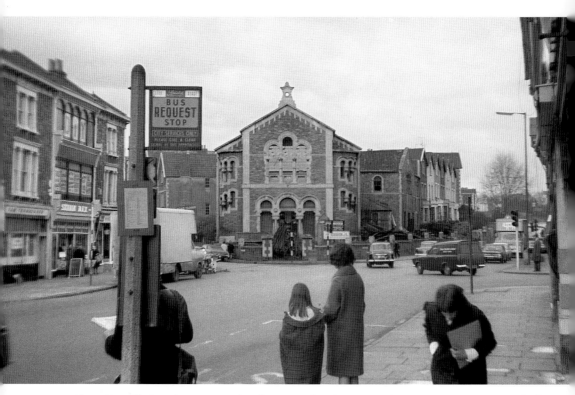

Above: Eastville Junction, seen on the afternoon of Friday 30 March 1973. Waiting passengers look to the distant curve in Fishponds Road for the approach of their bus; often, in those days, it was more a matter of hope than expectation. Stapleton Road branches off to the left. At the intersection of the two roads the chapel is being gutted in readiness for demolition; floorboards and rafters are piled up at the entrance and at the side of the building. An insipid low-rise office arose in its place, with a squared-off frontage that made no attempt to conform to the curve of the junction.

Opposite above: The Church of St Agnes, in a view along Newfoundland Road on Wednesday 19 January 1972. The area was to see great changes during the coming years. Today an equivalent view would be impossible because the camera position would be somewhere beneath the surface of Junction 3 of the M32. Concrete pipes have been assembled on the left, possibly for sewers or drainage, but perhaps to carry the waters of the little Horfield Brook under the new road to their disemboguement in the River Frome.

Opposite below: Winstanley Street, Barton Hill, taken from the junction with Barton Hill Road. Behind the camera is the railway; at the far end of the street is Queen Ann Road. The photograph dates from Friday 26 June 1970. An exchange of gossip takes place at a front garden gate halfway down the street and there is ... by the standards of the time ... a fair number of parked cars. This suggests that the houses were still occupied, but by the autumn all had been demolished, probably for the never-to-be-built Outer Circuit Road. Once the road scheme had been abandoned new houses were built and the course of Winstanley Street can no longer be traced.

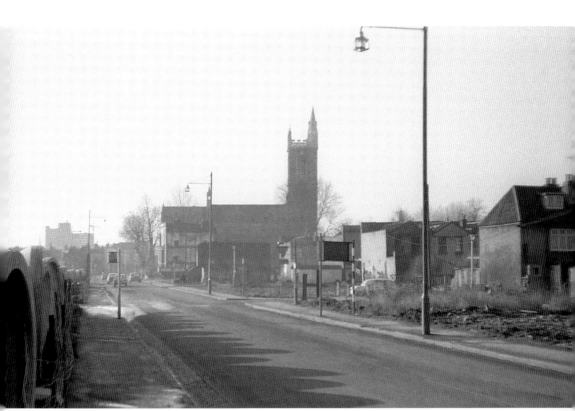

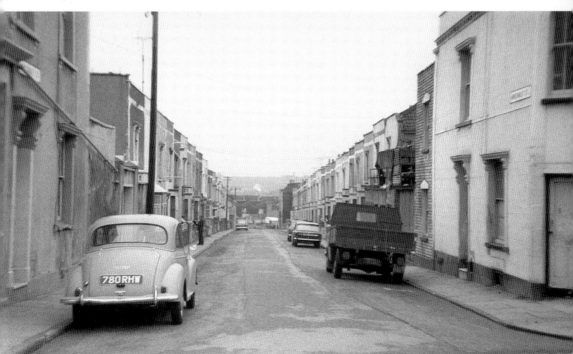

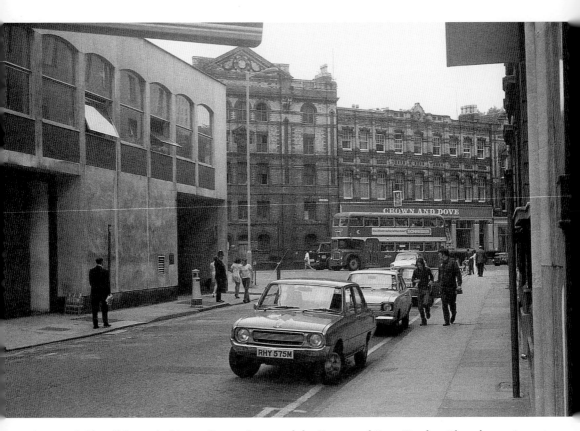

Bridewell Street, looking to Rupert Street and the Crown and Dove Hotel on Thursday 22 August 1974. Both the hotel and the five-storey pedimented building next door were demolished soon afterwards. With the Bridewell police station off right, police garages and offices on the left, the central fire station around the corner and magistrates' courts and solicitors' chambers nearby, these streets were the hub of civil order in Bristol. Today it would probably be branded the 'legal quarter'. Note, on the opposite pavement, one of the vents for underground electrical substations which, in less urbanised surroundings would be placed on the surface. As a small boy, when these vents were level with my face, I heard the hum of transformers rising from under my feet.

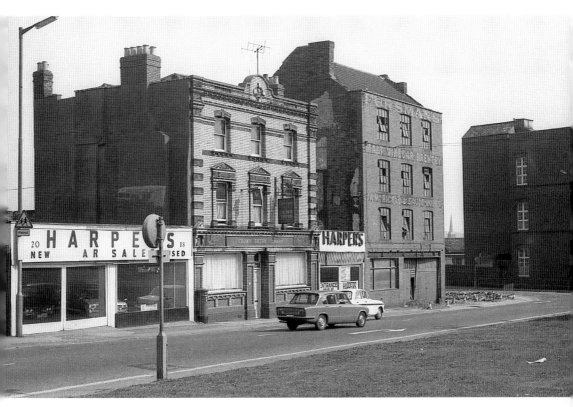

Taken in appalling heat on Sunday 3 August 1975, this photograph shows the north side of Lawford's Gate, St Jude's. The Crown Tavern is still in business, little changed apart from the replacement of its windows and signage. The car showroom on the corner of Wade Street later became, and remains, a convenience store. Window dressing is a lost art and its interior is screened from view by garish 'decals'. The faded letters on the frontage of the four-storey building proclaim it to have been Fursman's Sauce Works. Today, an early industrial building of this sort would be listed, but this one was demolished the following year. The empty plot on the corner is now occupied by a building set back to ease the path of traffic into Pennywell Road. On the far corner a generic block of flats has arisen.

Above: This had been the approach by rail from the Midlands, and it looks almost as though the Midlands had come down the line to Bristol from some car-producing, red-brick suburb of Birmingham. The railway line had closed a few weeks before the photo was taken on Monday 9 March 1970. The group of factories on the left belonged to Robinsons, the paper and packaging manufacturers, and Parnall's. The bridge carries Forest Road over the line and beyond the second bridge were the buildings of Fishponds station. This was during the five-year Standard Time experiment, which was, in effect, year-round summer time. Sunset was an hour later than we are used to at this stage of the year and I had wandered out to take this snap after watching the six o'clock news. The experiment, unpopular with farmers, especially in Scotland and the North, was not perpetuated.

Opposite: Although without the characteristic polychrome brickwork of the style, the Rowe Brothers warehouse in St Thomas Street was usually considered an example of 'Bristol Byzantine'. By an unknown architect, the building featured the typical deeply recessed windows in arcades of diminishing size from bottom to top. The top storey must have been either an addition or the replacement of parts lost to incendiary bombs. On the left of the photograph, taken Monday 12 July 1971, is part of the Iron & Marble Company's offices, another distinguished Byzantine building with a curved frontage at the flat-iron junction with Victoria Street. Both buildings were demolished in 1972 and replaced by an especially lamentable block with a chiselled-off frontage at the Victoria Street corner. The 1950s buildings in the distance were constructed over bomb damage: the Victorian buildings survived the war, but in the end it made no difference.

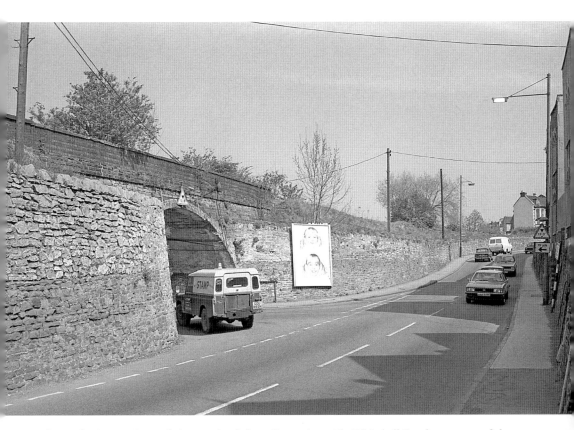

Above: The impressive wall that retained the railway alongside Whitehall Road, now part of the Bristol–Bath cycle path. Leaving aside the conversion from public transport to recreational use, the main impression today is of the proliferation of greenery. These things are all very well in their way but, as the ill-tempered architectural critic Ian Nairn pointed out as long ago as 1955, they have the effect of blurring the distinction between what is urban, suburban and rural. The suburbs, he said, were not so much growing as spreading ... out into the country, but also in towards devitalised city centres, leaving 'an even spread of traffic roundabouts, wire fences, preserved monuments, bogus rusticities, gratuitous notice boards, car parks, bungalows and Things in Fields'. He called this universalisation of our town fringes 'Subtopia'. Events have developed in ways Nairn could not have foreseen, but his basic premise has proved accurate.

Opposite: Durable letters of gold continue to advertise the modestly priced wares of Usher's, the Trowbridge-based brewer, from the chimney stack of the Palace Hotel, at the top of Old Market Street. We are looking up from West Street on Sunday 3 February 1974. Even then it had been a very long time since a bottle of beer cost the equivalent of 2½p. Traces of an earlier advertisement show through from underneath. The Palace, often described, on account of its ornate Victorian interior, as a 'gin palace', was nothing of the sort; it was built on the promise of trade from the Midland Railway's terminus at St Philip's. The sign gradually became illegible and the final traces were removed during renovation. Usher's also lives on in ghostly form, as a brand name owned by the Wychwood brewery.

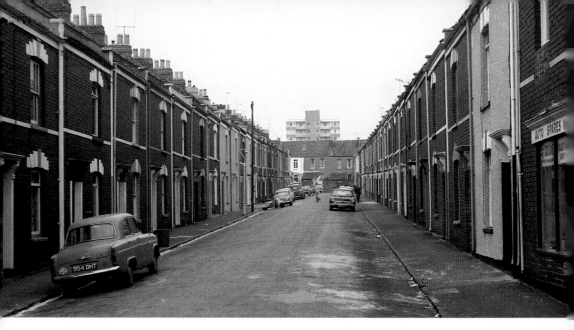

Hanover Street, off Avonvale Road, where Barton Hill merges into Redfield, seen on Saturday 20 April 1974. The distant flats were in Church Road, Redfield. The closest car is a Ford Prefect; I think it had a three-speed gearbox with 'column change'. It is a pity that the unified appearance of the street should already have been compromised by an outbreak of pebble-dash. Today, the original brick frontages are in a minority. The 'corner shop' on the right (there had been another on left) had become a car spares shop, but is now a dwelling.

The junction of Muller Road and Fishponds Road has an honoured place in the annals of Road Research: it was the site of Britain's first ever mini-roundabout. The early experimental version was a shallow wooden cone, which proved susceptible to displacement by the rear wheels of lorries. It was replaced by the simple painted-on version that has been with us ever since. The photograph was taken on Saturday 26 September 1970. The railway bridge in the distance was scheduled for demolition the next day, although the work was not completed and carried over into the following weekend. The line was presumably constructed to give goods from Avonmouth Docks access to the Midland Railway's route to the north. I never saw it used. For a line only a mile long it had a great deal of civil engineering. The demolition – by explosives in 1968 – of the curved, thirteen-arch viaduct across Stapleton Road, familiar to all attendees at Rovers' home matches, is famous in local folklore. The 'dip' in the road beneath the bridge was provided for trams to pass under, but has now been levelled.

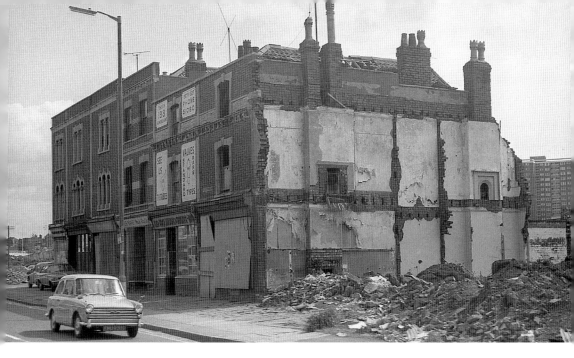

Above: It was probably foreseen that people would eventually object to the obliteration of large parts of their familiar surroundings: the authorities got on with the job and completed as much as possible before people noticed and started complaining. To make it more acceptable the process was sometimes described as 'slum clearance'. These were certainly not slums. What might people now pay for substantial three-storey houses close to the city centre, with high ceilings, deep wainscotting, picture rails and cast-iron fireplaces? What gentrification might have arrived if these houses had stood for another decade or two? As a boy I was always fascinated, when our bus groaned to a halt outside, by the painted signs on Helmore & Hunt's shop, showing wireless valves and television tubes. The shops faced up St Nicholas Road, off left of this view; today their site is occupied by concrete steps and a ramp leading to a footbridge across the dual-carriageway extension of the M32. The photo was taken on Sunday 1 June 1975.

Below: On Friday 29 August 1980 Hillman Hunters and Ford Capris await the return of their owners among puddles where quayside warehouses once stood. The buildings in the distance were those grouped around the junction of Bathurst Parade and Wapping Road, on either side of the Louisiana public house. The backs, turned away from public scrutiny, are coated with unpretentious 'Bristol black' render. Buddleia flourishes among drainpipes, rotten window frames and crumbling outbuildings. In the foreground came Merchants Quay and Challoner Court. In sanitised form the buildings remain, but I doubt that much of their original fabric survives, and certainly not those lively chimney pots. The tower of St Paul's Church is visible at the right edge.

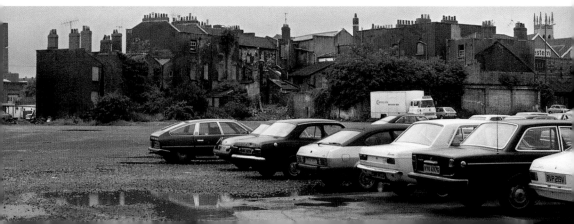

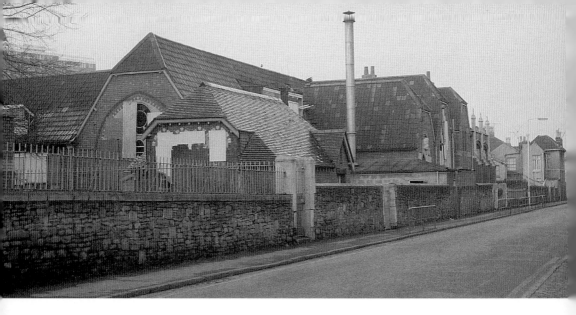

Above: Looking along St Gabriel's Road, Easton, into Lansdown Road towards Stapleton Road and the Lebeck pub (not yet known by its pseudo-authentic name, the Lebeqs Tavern). St Gabriel's, a Church of England school, was all of a piece with the neighbouring church, seen in an earlier photograph and presumably designed as part of a single job by the same architect, J. C. Neale. Modern schools usually consist of a jerry-built central structure surrounded by prefabricated annexes, Portakabins and brick hutments added over the years according to the availability of funding. All have a threadbare, down-at-heel look, shared with hospitals. St Gabriel's was closed in 1973 and is seen here on New Year's Day 1974. It was demolished in the spring of 1975.

Below: A view from one half of Temple Street into the other, the two having been separated by the construction during the nineteenth century of Victoria Street. The sign of 'Ye Shakespeare' is seen on the left. The houses beyond are derelict and shuttered with corrugated iron. They survive, but in remodelled form and probably gutted internally. In the distance, on Saturday 19 January 1974, we glimpse the remarkably long-lived 'temporary' flyover, which finally disappeared when the Temple Meads 'gyratory' scheme was introduced. Also glimpsed are the Grosvenor Hotel and parts of the Mardon, Son and Hall complex.

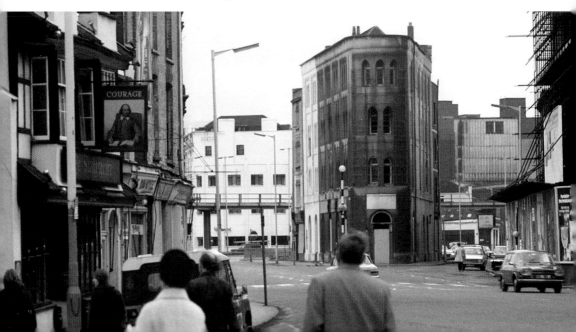

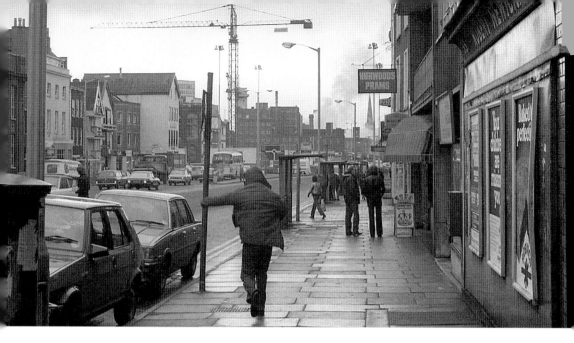

Above: When Rasselle's and Peters closed, Hurwood's, the pram shop, whose sign is seen on the right, must have been the last of Old Market's pre-war businesses. The street had been in slow decline since the closure of the tram system and construction of the wretched Inner Circuit Road underpass. Bristol's shopping centre had once stretched in unbroken continuity from this, its downmarket end, via Castle Street, Mary-le-Port Street and Park Street to the smart shops in Queens Road. Now Old Market Street was cut off. Its great width is, of course, the relic of the medieval old market, held here where all roads from the east and north entered the city by Lawford's Gate. On Monday 22 December 1980, the traffic moans through on its way to somewhere else. With Christmas only a few days off, the normally unfrequented pavements are a little livelier than usual. Steam rises in the distance from Courage's brewery.

Below: Today only a few yards of Cattybrook Street remain. Behind the camera, becoming Jane Street, it joined Church Road, with the Globe cinema at the corner. The cinema was still standing at the time, but came down during the summer. At the right edge of the photo, taken on the evening of Friday 30 March 1973, the street joined Russell Town Avenue. Off left is the railway and Lawrence Hill station. The car in the foreground was the luxurious (and thirsty) Austin 110 Westminster and I am reliably informed that the digger standing in the road was a Case 580. Remarkably the house and its lean-to addition are still standing, surrounded by the buildings of the City Academy.

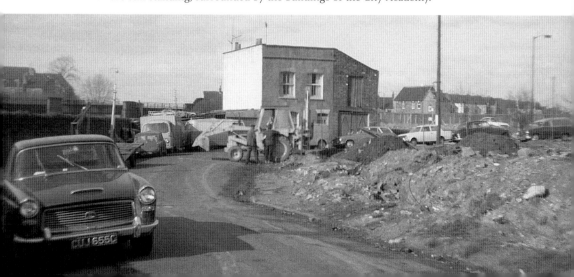

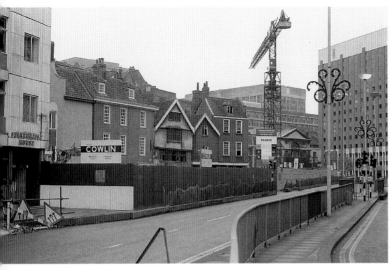

Acknowledging that it had made a mistake in permitting the demolition of ancient buildings in Christmas Street, the City Council took measures to rebuild on the site and re-enclose the foot of Christmas Steps. In this quiet pre-Christmas Sunday morning view, taken 5 December 1982, work is suspended for the weekend. A new office development, called Centre Gate, arose to a design by the Moxley Jenner partnership.

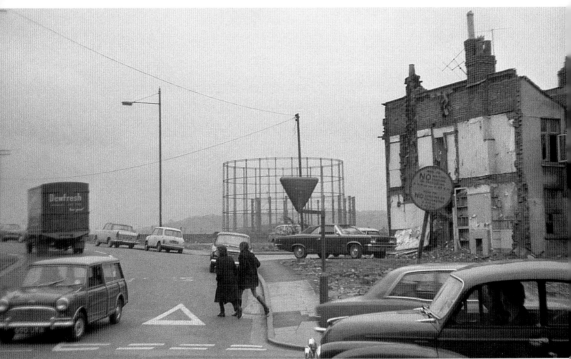

Above: Looking along Barrow Road from its junction with Clarence Road on Friday 1 May 1970. Not long afterwards Barrow Road was rerouted to meet the vast new Lawrence Hill roundabout, then being laid out a few yards to the left. A few houses remain in Catharine Street, but all else has gone. The Dewfresh lorry would have been bound for the Dewhurst butchery firm's premises in Jarvis street. An interesting selection of what are now classic cars is visible, including an interloper from across the Atlantic. The mini fashions of the 1960s were about to give way to their antithesis, the maxi style, which is less fondly remembered and, indeed, largely forgotten. The changeover is neatly represented in the costume of the two young people crossing the road.

BRISTOL
A Portrait
1970–82